♡ Happy Kitty Bunny Pony

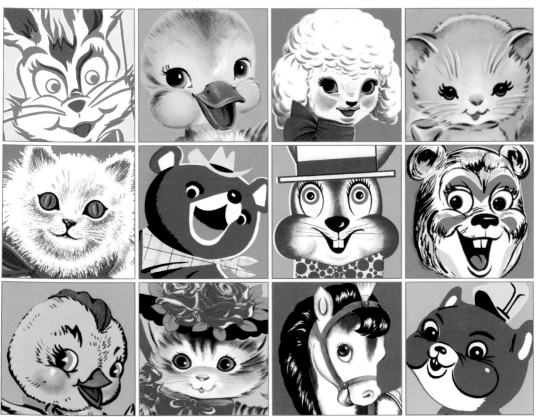

A Saccharine Mouthful of Super Cute

Charles S. Anderson Design Company
Text by Michael J. Nelson

Harry N. Abrams, Inc., Publishers

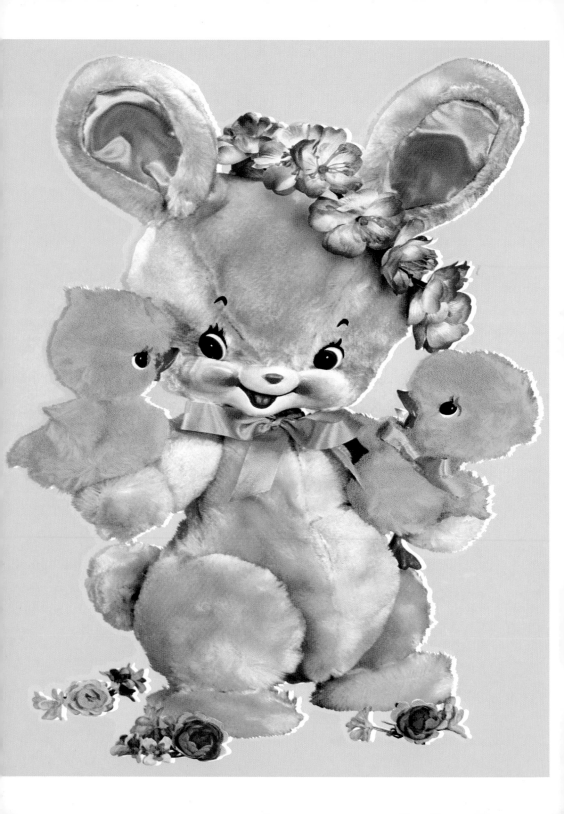

Pop ink

Happy Kitty Bunny Pony

A Saccharine Mouthful of Super Cute

Where do we begin to examine the staggering enormity of the question "What is cute, anyway?" Webster's Dictionary defines "cute" as "slightly wet; damp or humid," which is–hang on. I'm sorry, that's the definition for "moist."

"Cute" is "obviously contrived to charm; precious." With this in mind, it's easy to see that America has not always been a vanguard on the front of adorableness. In its infancy, the United States seemed more focused on its efforts to break free of a tyrannical King George and to scrape together enough money to spruce up the White House after the British torched it than to create pictures of big-eyed children or plush animals with chubby little tummies. Luckily, the country's priorities soon changed.

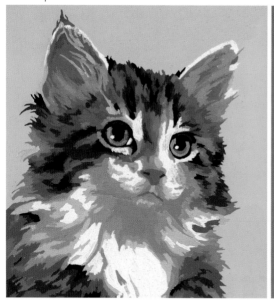 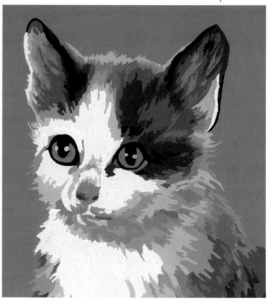

The path to cuteness was not an easy one. In 1889, America, hoping to gain the advantage in the race to plush-toy supremacy, assembled a secret commission to develop an adorable fuzzy bear. Spain, the unquestioned leader in world cuteness production at the time, got wind of the plot and sent their armada to America to stop development of the bear by force. American troops met the armada in Cuba and, led by Teddy Roosevelt and his so-called Rough Riders, routed the superior Spanish forces. In tribute, the toy was redesigned to resemble the bespectacled Roosevelt and nicknamed the "Teddy Bear." (Subsequent attempts to recreate the popularity of the Teddy Bear, e.g., the "William Howard Taft Squirrel" and the "Warren Gamaliel Harding Rabbit" were hopeless failures.)

The first part of the twentieth century saw major advances in the cute industry. Walter Elias "Walt" Disney and his brother, Roy, had been toying for some time with animating a whimsical little creature they called "Mickey Flatworm." After some disappointing test screenings (at which many audience members left crying), they retooled him as "Mickey Mollusk," "Mickey Spitting Cobra," and "Mickey Lungfish" before finally settling on a much more cute and cuddly "Mickey Mouse."

Once Disney established the commercial viability of darling little creatures, imitators flooded the market, and in the three decades following Mickey's debut an estimated 154,908,934 animated rodents alone were introduced. In response, Disney sent out vast armies of lawyers who cut a swath of lawsuits across this land such as has never been seen. Within a year, every man, woman, and child in America was a defendant in a Disney lawsuit. Finally, in 1948, Disney sued the mice of America and won. As a result of this landmark decision, mice, due to the enormous liens against them, can't buy or sell any pieces of property.

The post-WWII era was an important epoch in the development of cuteness, as the nation and its children embraced their more commercial side. Cereal

mascots in particular enjoyed enormous success, so much that when Tony, a six-foot, four-hundred-pound Bengal tiger, was introduced in 1952, children, instead of running, shrieking, and hiding under a throw rug, were delighted, and consumed his cereal by the metric ton. Similarly, when the rascally alien Quisp arrived on Earth in 1965 and resembled nothing so much as a deformed bulb of flesh wearing pajamas–from whose cranium protruded a small clump of weeds, and out of that a propeller–he successfully hawked his eponymous cereal (while no doubt helping inspire untold millions of alien-based nightmares.)

By the 1970s, the groundwork had been laid, and cute peddlers began their full-out assault on the American public. Meet Holly Hobbie, Strawberry Shortcake, and Precious Moments–if you were even mildly allergic to cute, you had little choice but to throw yourself out a window and hope for death. (To be fair, many had the same reaction upon first seeing Leif Garrett.)

Though *Happy Kitty Bunny Pony* may not be the final word on cute, it is a testament to the endless inventiveness and tireless efforts of those brave Americans who devote their lives to charming the living hell out of their fellow citizens.

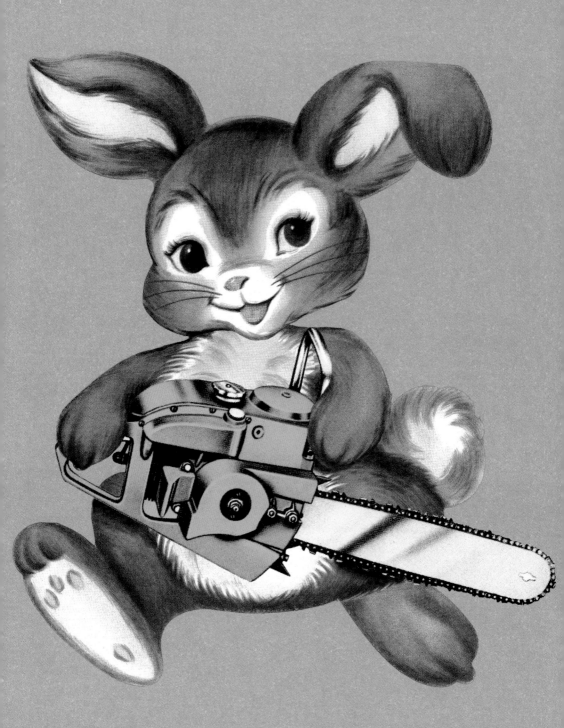

HAPPY KITTY

Is there anything in this world that warms the soul more than the sight of a smiling, fuzzy-wuzzy, happy kitty? Nothing in this world. Unless . . . Hey, is this kitty up to something? Look more closely at that smile. Is it a smile of guileless wonder? Or one of cold, calculating malice? And those eyes—black, bottomless pools of mindless evil. That little girl! She doesn't know that she's holding a vicious ball of cruelty in her tiny, innocent hands! Run, little girl! Drop that kitten and run! Don't look back! Run to the nearest dog park and hope for the best.

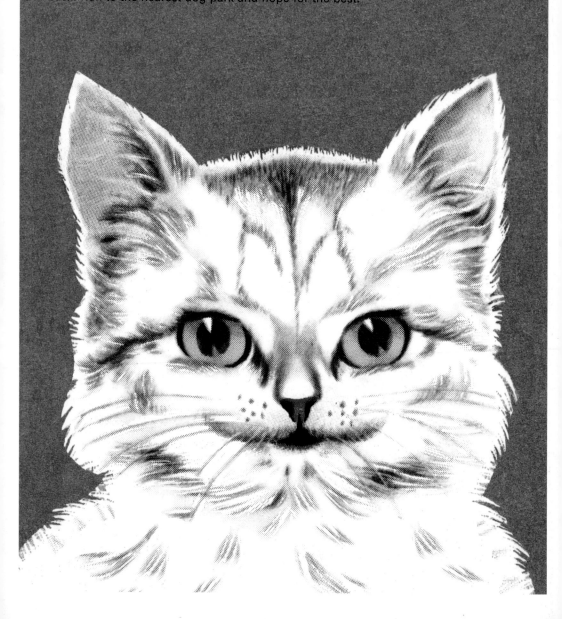

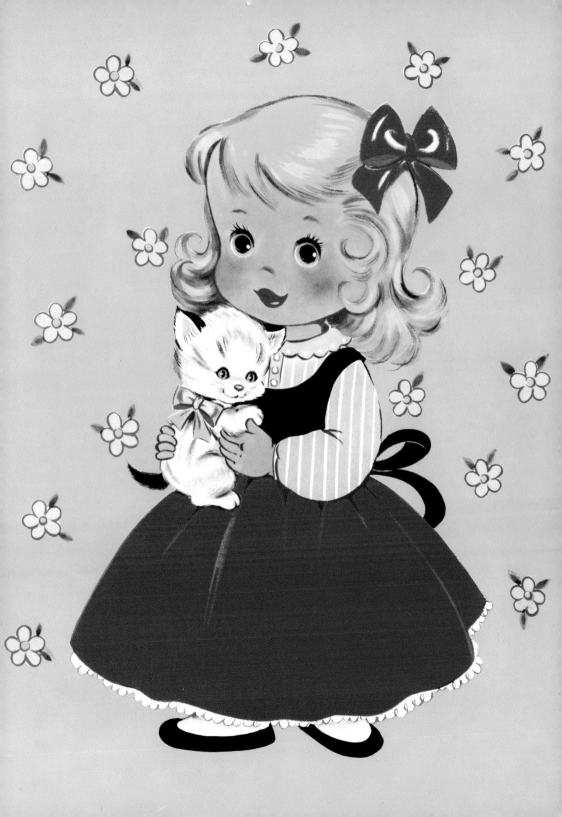

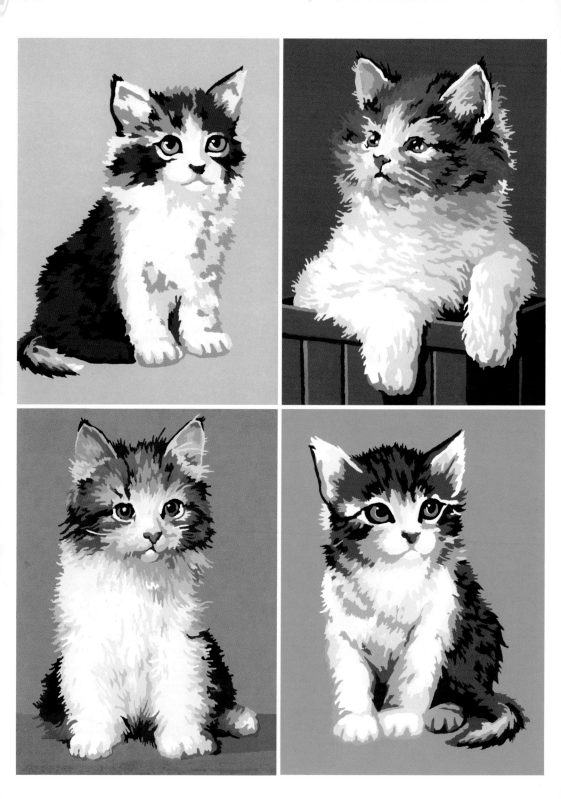

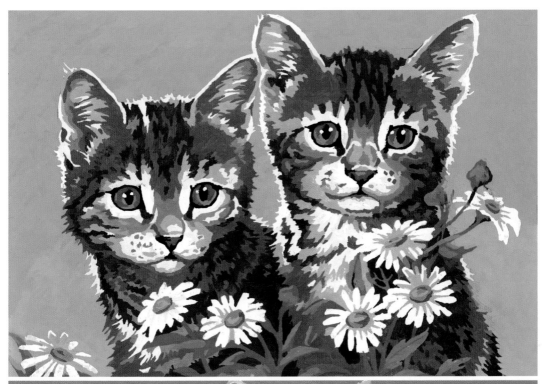
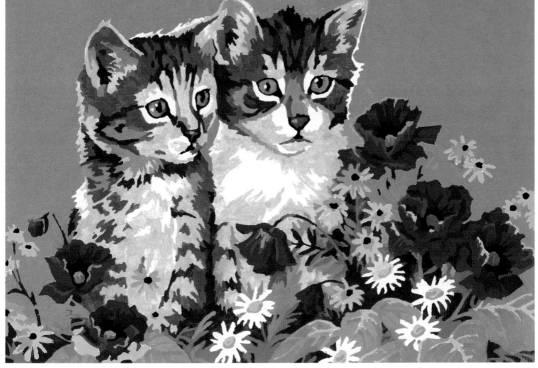

CatFact®: A single cat can be responsible for the deaths of more than 100 birds and small animals every year. (But not this cat, of course. His fused back end and peglike front leg make it difficult to move stealthily. And not the cat on the opposite page, either. His oversized head makes him enormously top-heavy. The fat duck in the orange tree has nothing to worry about.)

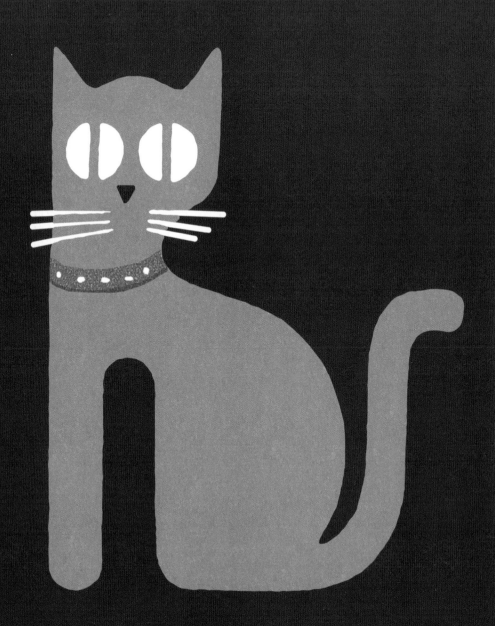

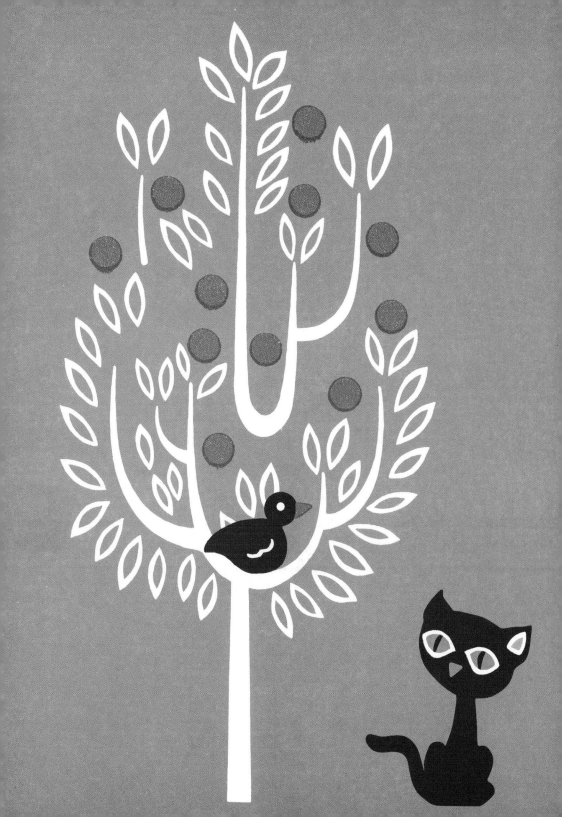

Cats are adorable, yes—unless you're a mouse! If you are a mouse (obviously, if you're reading this, you are not), you tend to view cats as giant claw-wielding horrors. Mice want nothing more than to prowl in the dark, and spread the Hanta virus. Cats have a different plan for them.

Sooo cute. You might even forgive this little muffin for digging into your gym bag and stealing your racquetball, pawing at it, and drooling all over it right before a big match. You might . . .

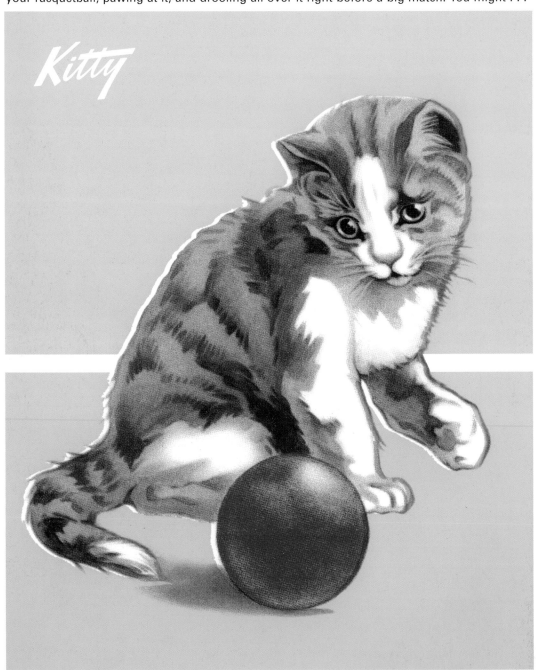

Almost everything they do is adorable. Even off-loading a huge batch of fetid stool into a shallow pan of dusty gravel becomes a charming act when performed by a big-eyed kitty.

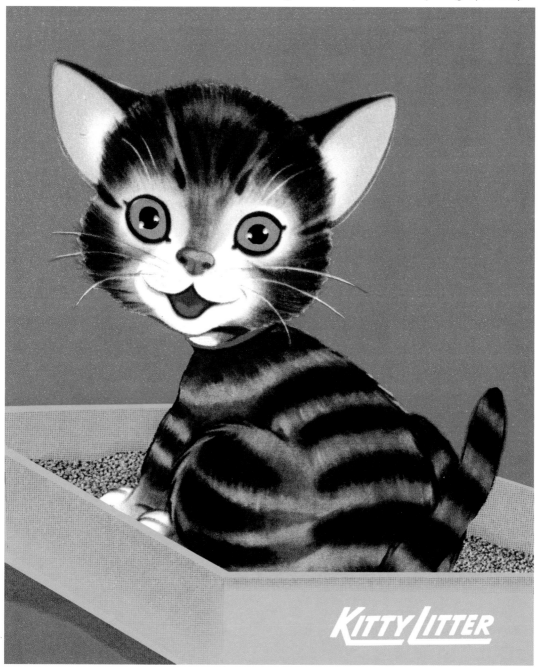

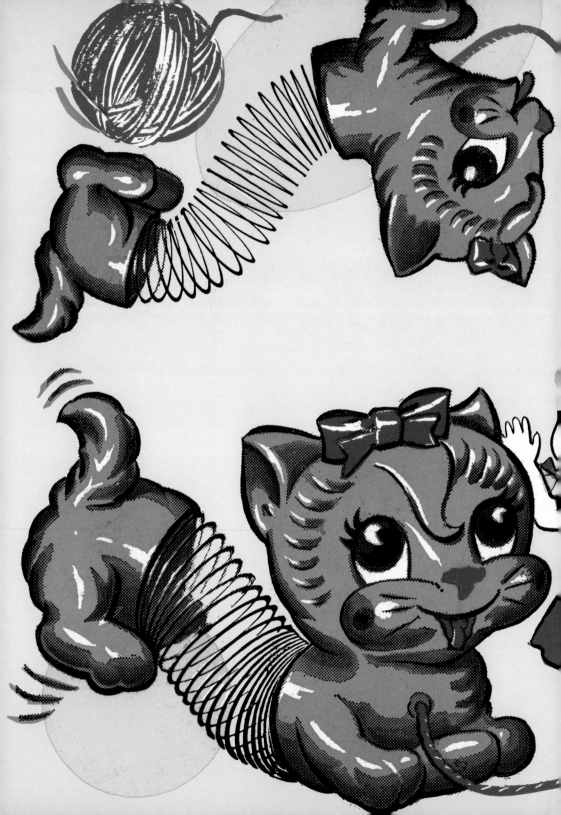

CatFact®: Cats are amazingly adept at jumping and can, without even breaking a sweat, leap five times their own height! If, like this cat, their bodies consist of highly reactive molybdenum springs, they are able to leap more than 900 times their own height. That means that this specimen, at a height of approximately three feet (assuming the girl is to normal-girl scale), is capable of leaping 2,700 feet into the air. Watch that landing!

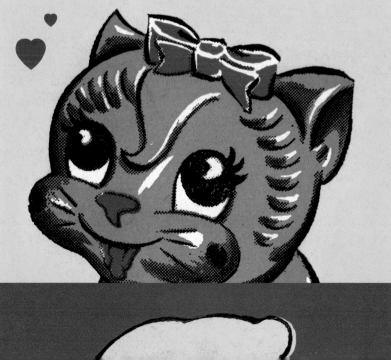

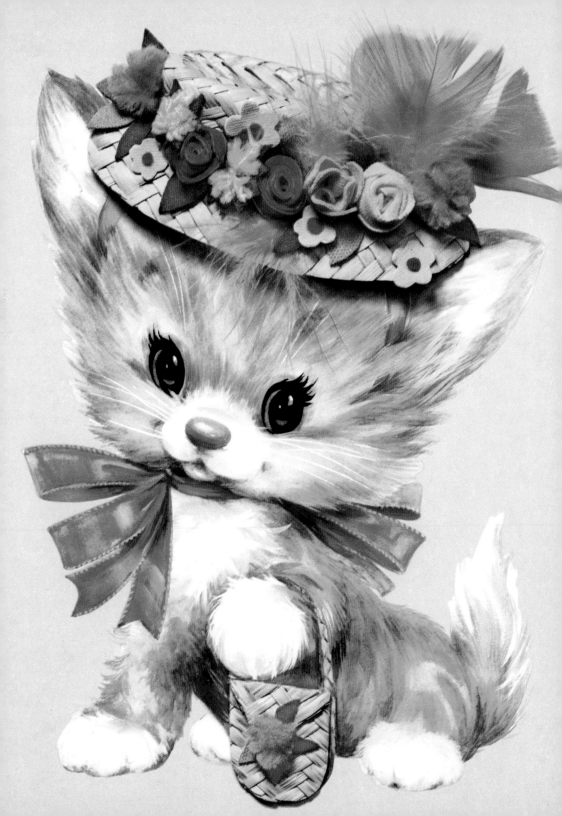

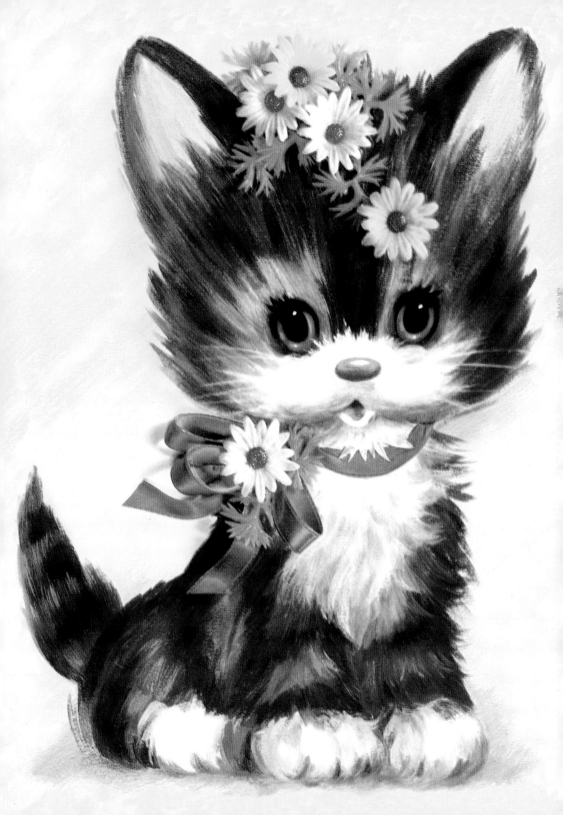

These darlings really pump up the charm. Note that while lolling among the flowers, they both

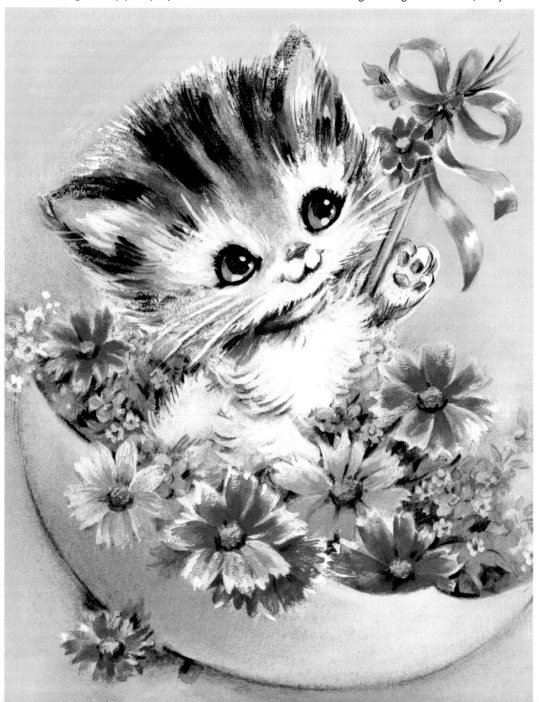

are wearing eyeliner and mascara. Yes, staying young and desirable is difficult, even for kitties.

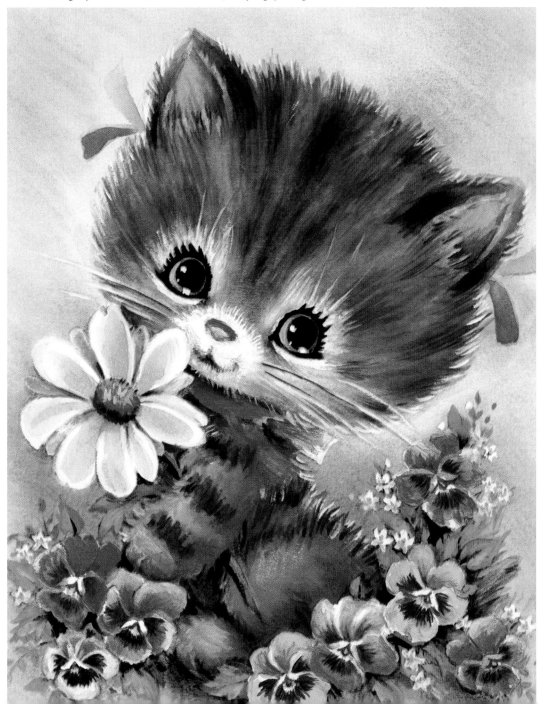

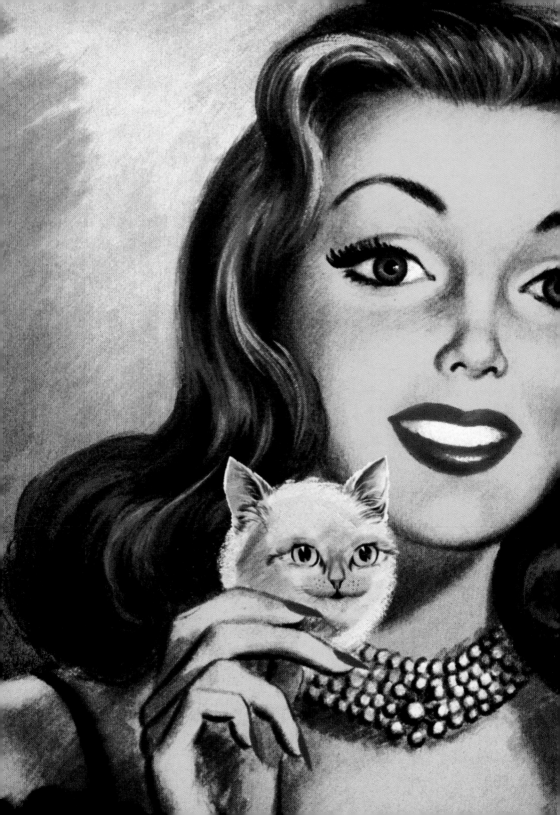

This bit of nostalgia is a stark reminder of a dark period in feline history. For many years, mummified cat heads (sans skull) were the ultra-chic powder puff. Pressure from animal-rights groups and synthetic puff technology developments eventually elbowed cat head-based puffs out of the market. Still, many women remember their feline applicators as being the best they ever had.

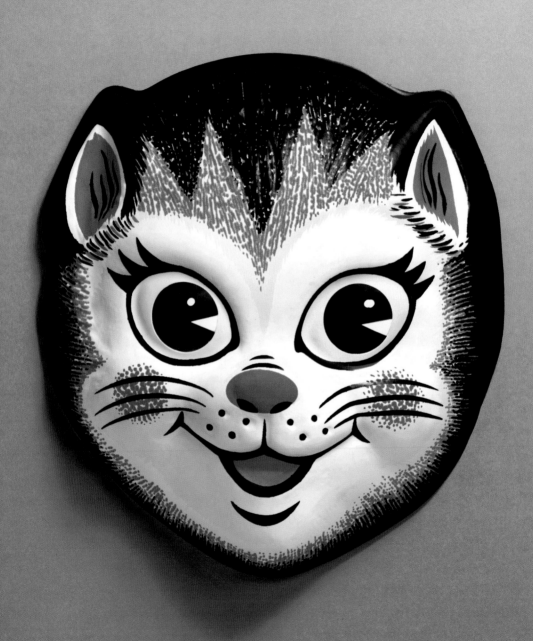

This cat mask contains in its eyes a not so subtle advertisement for Pac-Man.

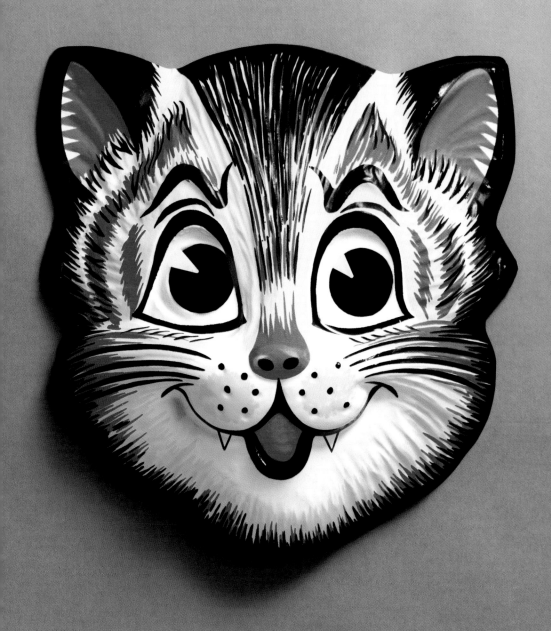

And this one, to give trick or treaters a touch of menace, bears just a hint of its teeth.

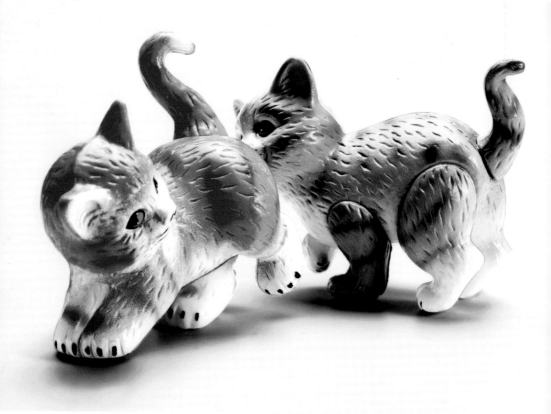

Phet and Ploy, a pair of Siamese cats, were, according to their owner, deeply in love, and married in a $16,000 ceremony held in Thailand's largest discotheque. (Several years later, they bitterly divorced.)

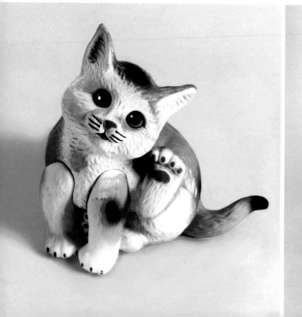

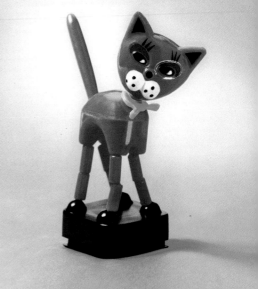

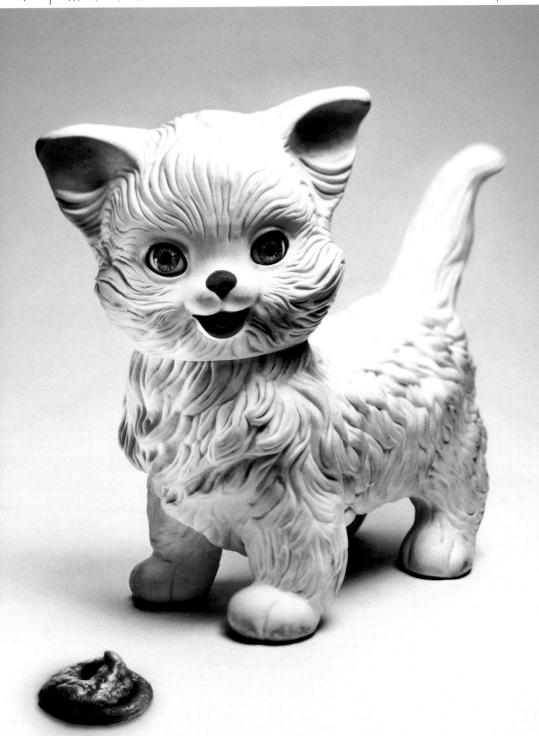

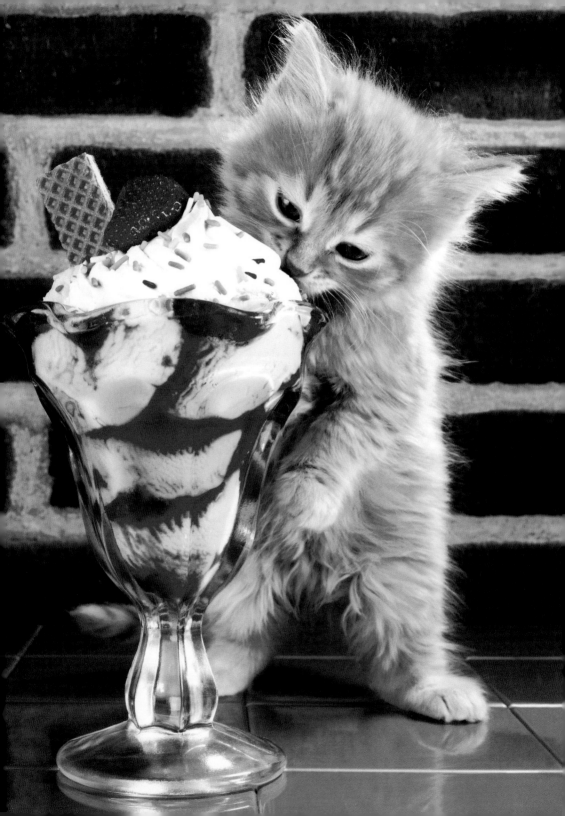

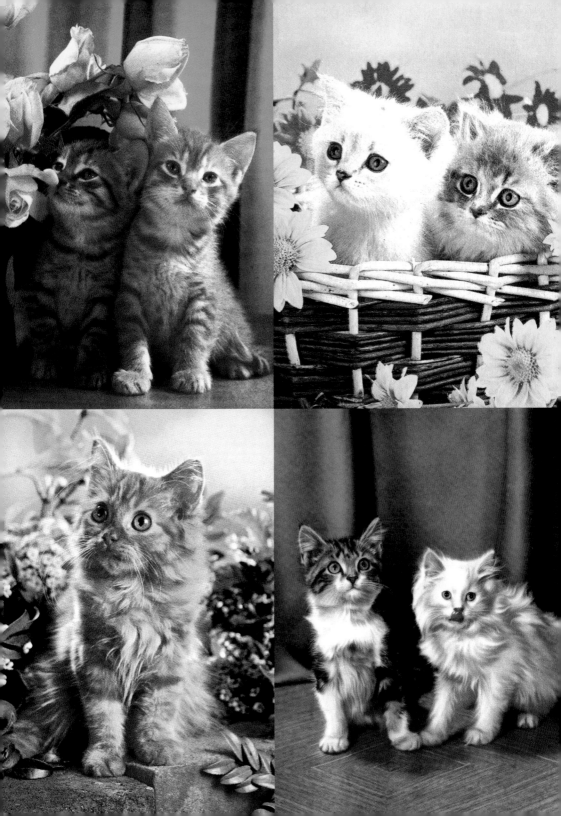

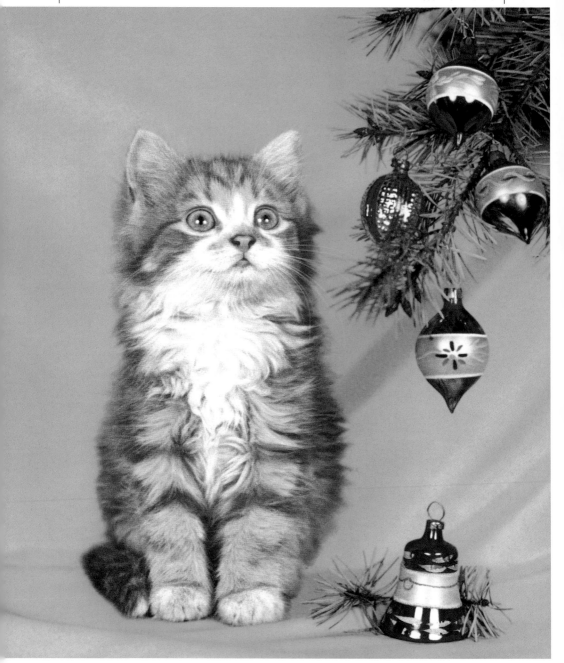

Buying a gift for a cat is hard, because cats have only the dimmest awareness of their surroundings. Get them a bell or, if that's too extravagant, a small clump of earth. Because, it will hardly matter.

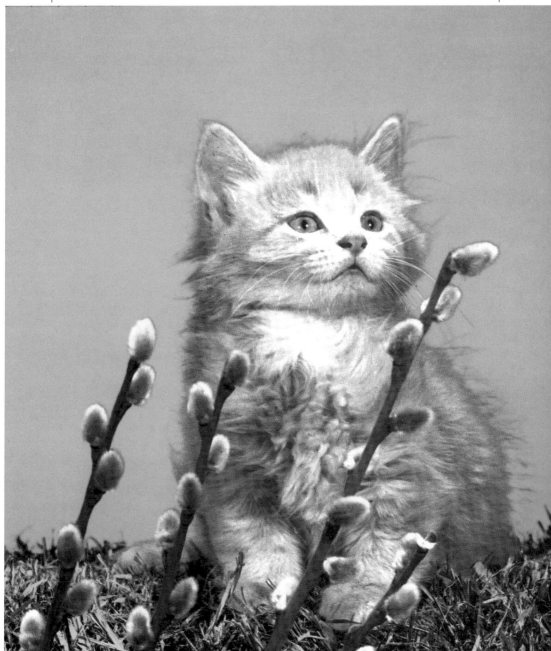

Is this sweet little fella aware of the incredible irony—a sweet little pussy wandering among the pretty pussy willows? No. Irony is beyond him. Again, dimmest awareness of their surroundings.

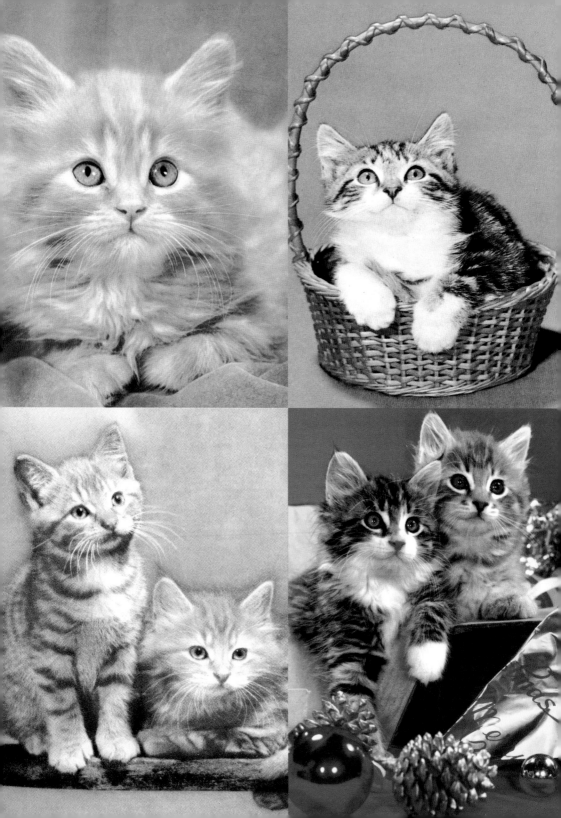

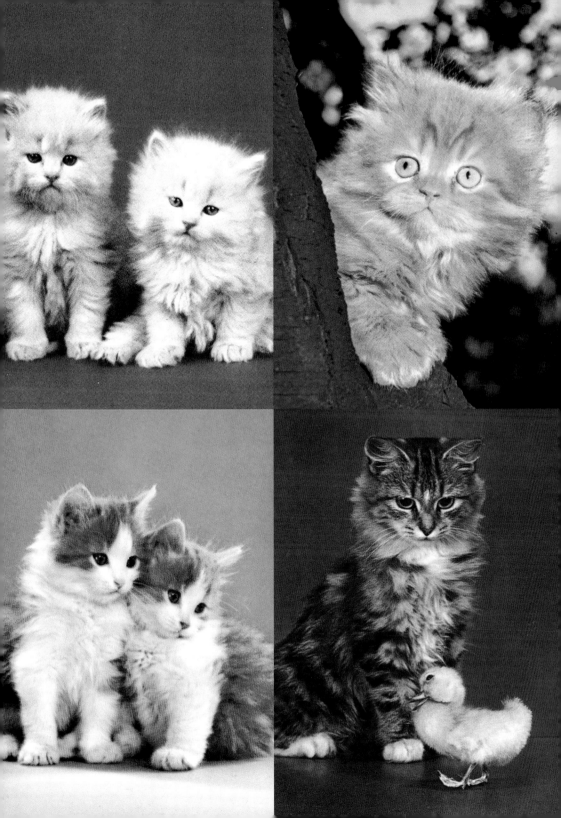

Yarn looms large (no pun intended) in the lives of kittens. No one knows for sure why it is that cats love it so. Perhaps batting a ball of it around relieves their stress or sharpens their keen senses.

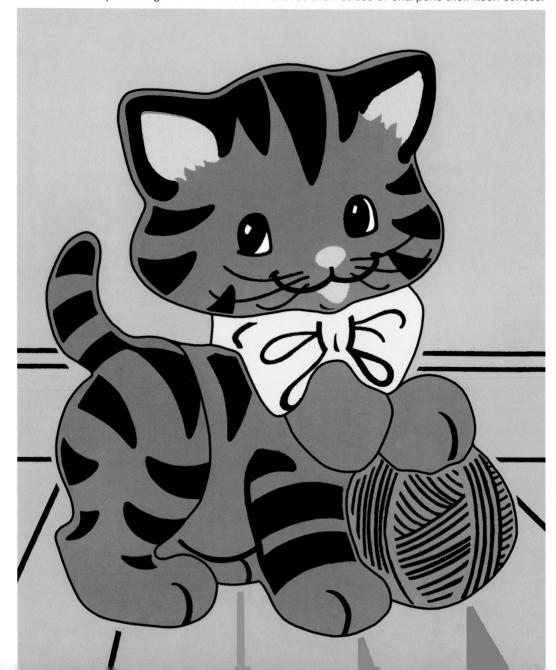

Or is it that playing with yarn satisfies an innate desire to inflict cruelty on small animals? As they claw at the yarn, are they imagining it's a terrified vole, the vole father of six adorable vole children?

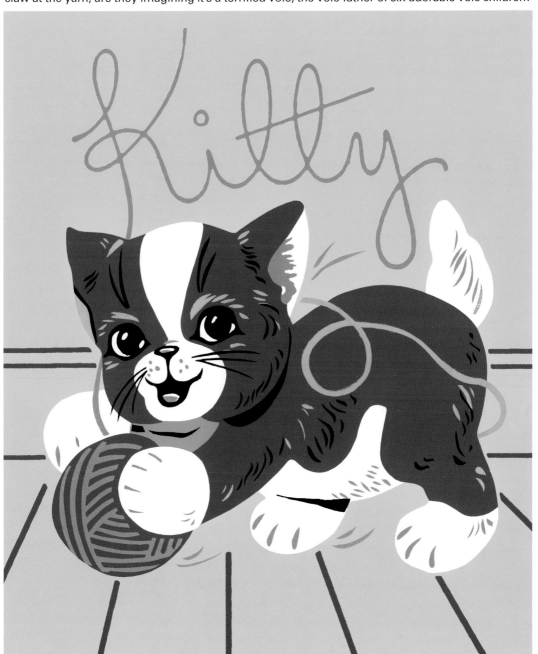

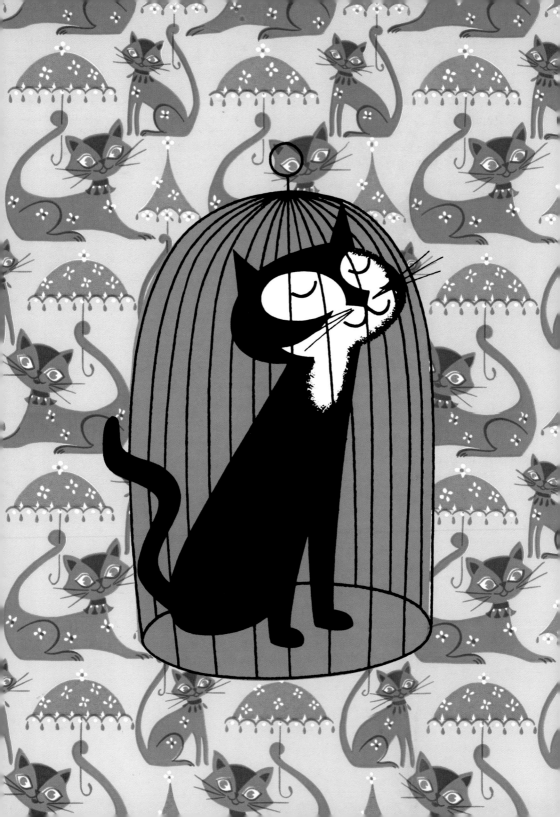

No small creature is hated as much by cats as the bird. Your average cat would crawl over his injured grandmother just to harm a defenseless sparrow. The reason is simple—jealousy. Cats can leap, yes, but they cannot fly. The vast majority of birds can leap and fly better than any cat. This unfairness has needled cats since time began. And rather than accept it, they have let their bitterness blossom into a culture of hatred. They're still cute, though.

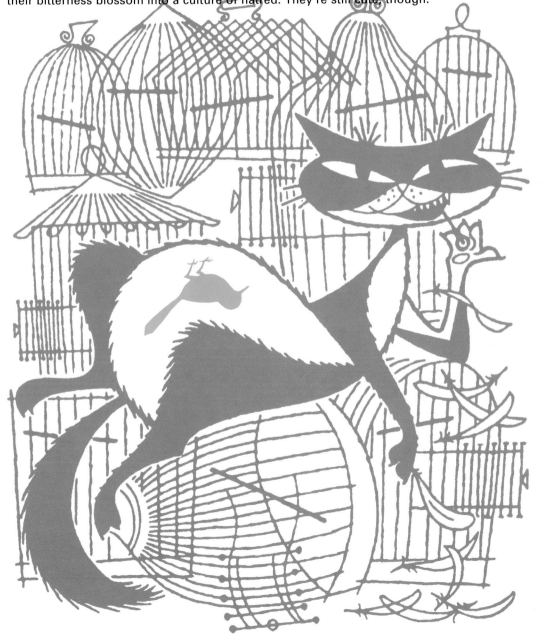

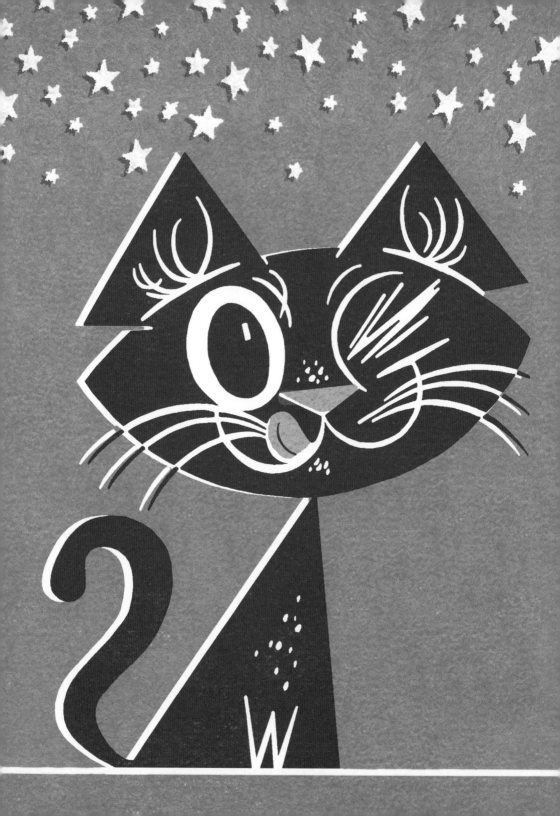

When it comes to their diet, cats can be discouragingly finicky. But one thing all cats adore—tuna in cottonseed oil! Cat owners have experimented with little success to vary their pets' diets. Just a few of those rejected foods: cling peaches in heavy syrup; chipotle peppers in adobo sauce; capers in balsamic vinegar; pickled onions in vermouth; and three bean salad.

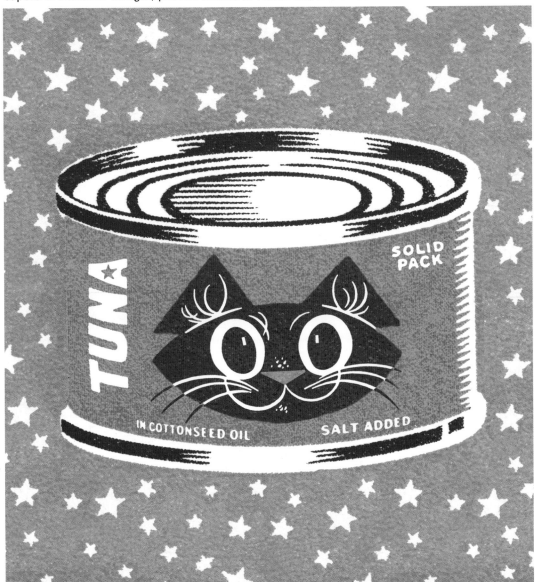

FLUFFY BUNNY

Bunnies! Wonderful, flufferful, huggable bunnies, those carrot-munching symbols of innocence, spring, and mind-boggling fertility. Take a big-eyed bunny, slap a polka-dot shirt on him, fluff out his tail, give him a big smile and long eyelashes, and have him leap playfully after a carrot and you've got a very potent package of cuteness. In contrast, the hare on the opposite page (hares are not rabbits, no matter how hard they try) has, at best, offbeat good looks and is not the slightest bit cute.

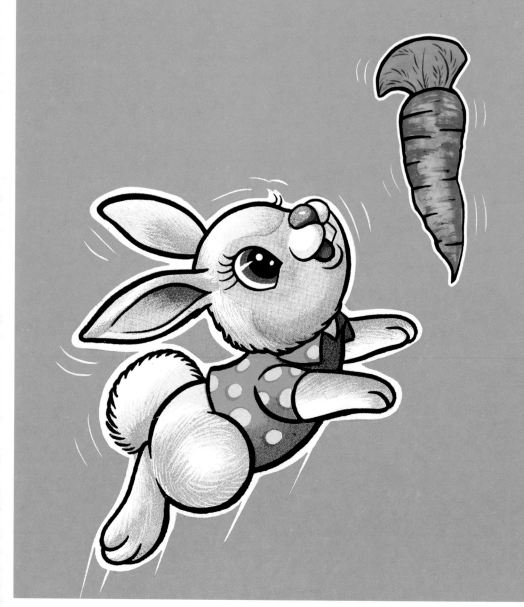

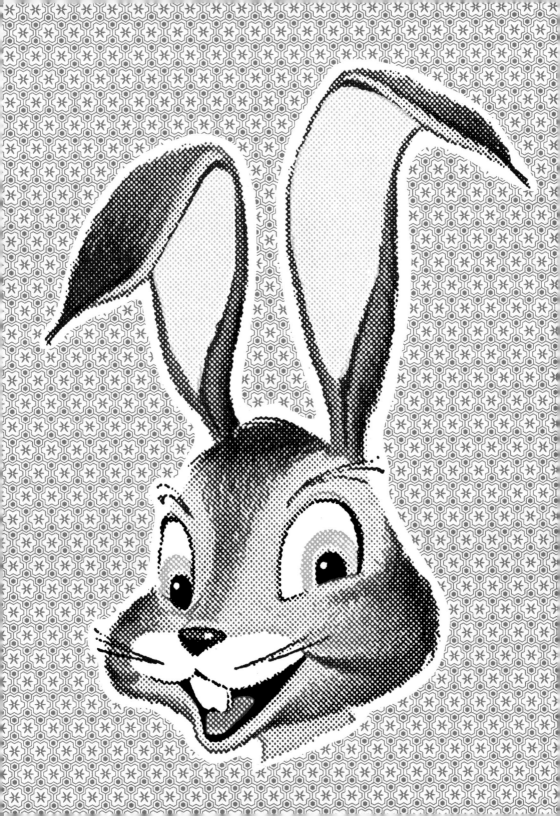

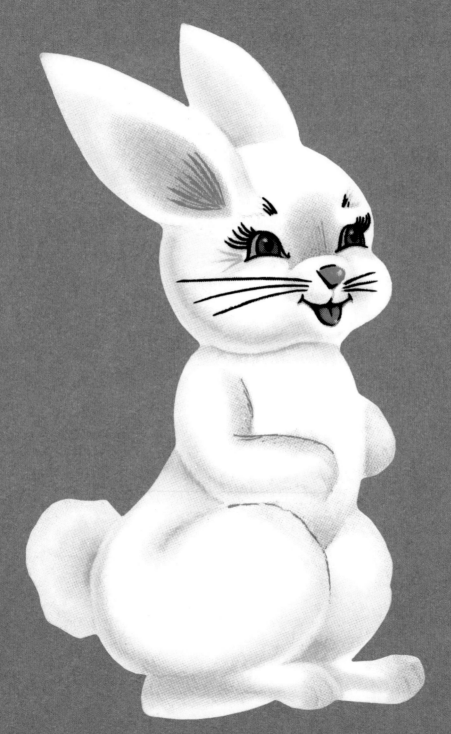

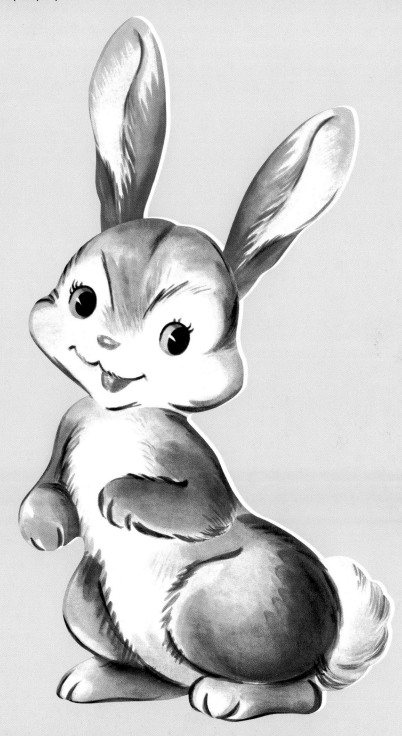

RABBIT

INFLATABLE

If you are lucky enough to have one of these captivating playthings, you know just how fun and how adorable they are. You also know that it's not wise to hug them too vigorously—the plastic seams are sharp and can abrade the skin or, at worst, flay it wide open.

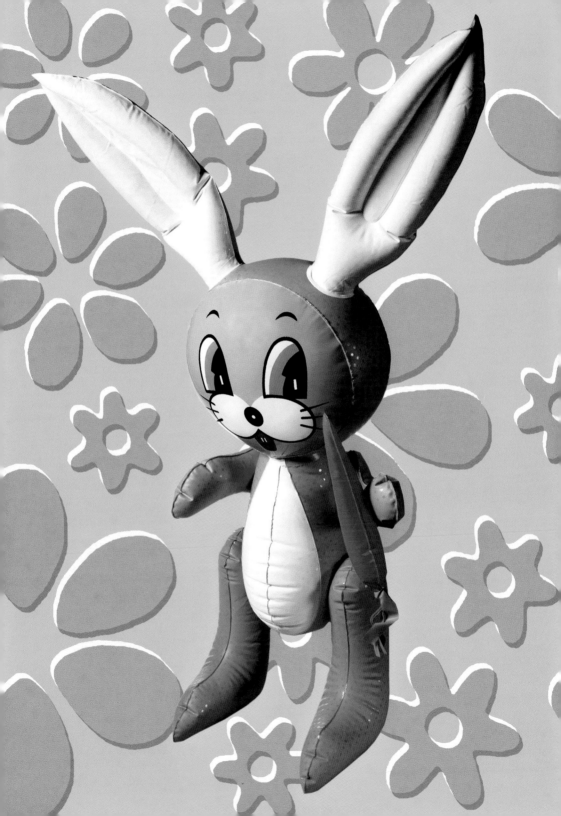

Whoa, it's like mind-blowingly cute, man. They're so trippy, you may not even notice that they are lambs wearing bunny costumes! For what sinister purpose, no man can really say.

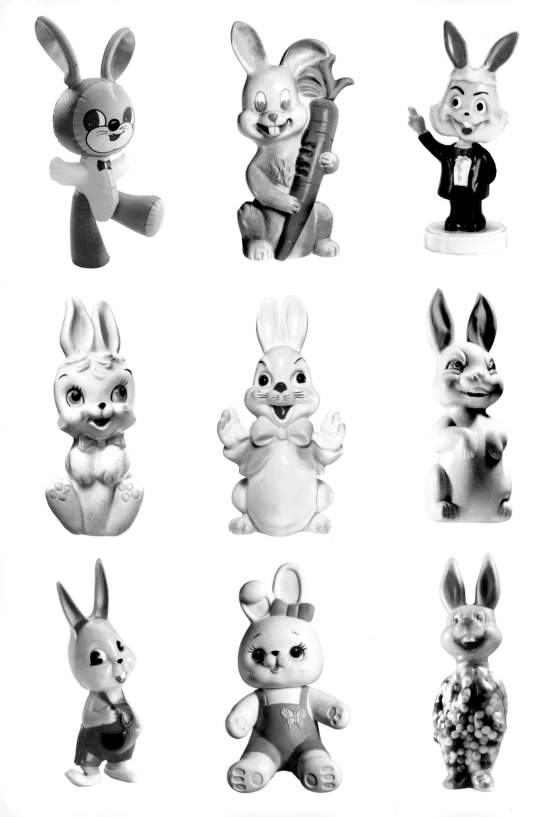

What are you going as for Halloween? A rare breed of cave rabbit with enormous irises (to help it see in low light) that has a look of surprise on its face and grapes perched upon its head?

Right out of the gate, bunnies are adorable. But you take a gaggle of egg-headed, chubby little baby bunnies wearing vests and jumpers, and you've got cute that could choke a horse.

Here is another hare trying his best to be bunny-cute. And though he does yeoman's work, leaping playfully about in a verdant wood, sniffing curiously at a dragonfly, let's face it, he fails. It's those overly long legs and freakish ears. In the cute war, bunnies kick major ass on hares every time.

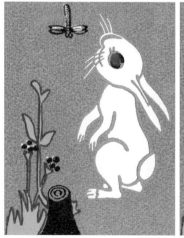
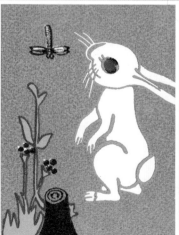
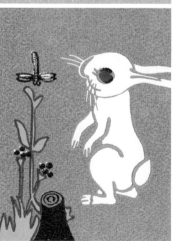

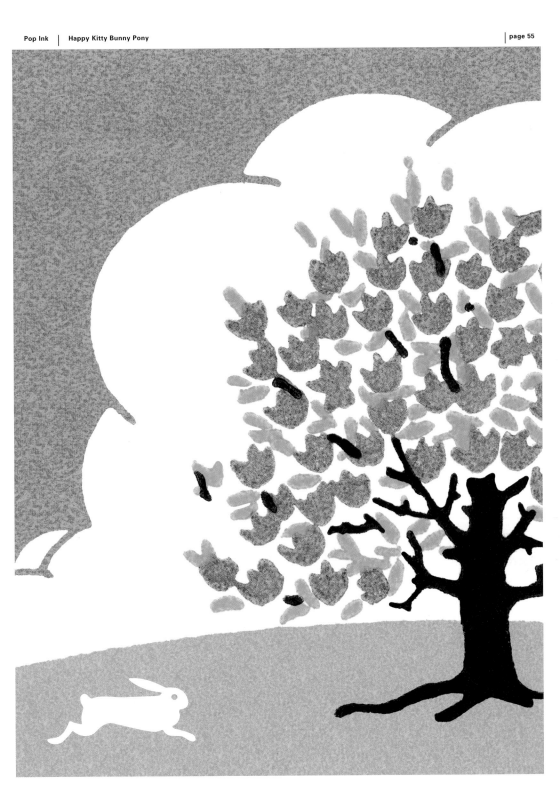

BUNNY LOVE

Bunnies are amazingly frisky and can't keep their lusty little paws off of each other. If conditions are right, that is, if the man bunny springs for a decent meal, says the right things, holds the lady bunny's paw in public, and keeps himself nice and clean, then he's bound to get himself some sweet lovin'—and just one month after the sweet lovin' comes a litter of some 4–6 baby bunnies! A lady bunny can crank out as many as 7 litters a year. Meaning that for a mere 7 bouts of sweet lovin' per year, over the course of 6 years, a guy's got to provide for 200 hungry little mouths. I ask you, man bunnies, is it worth it?

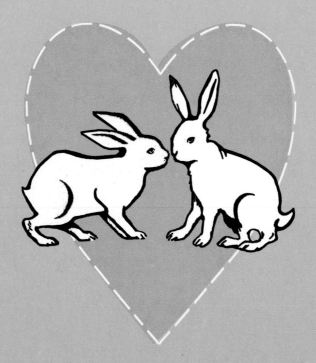

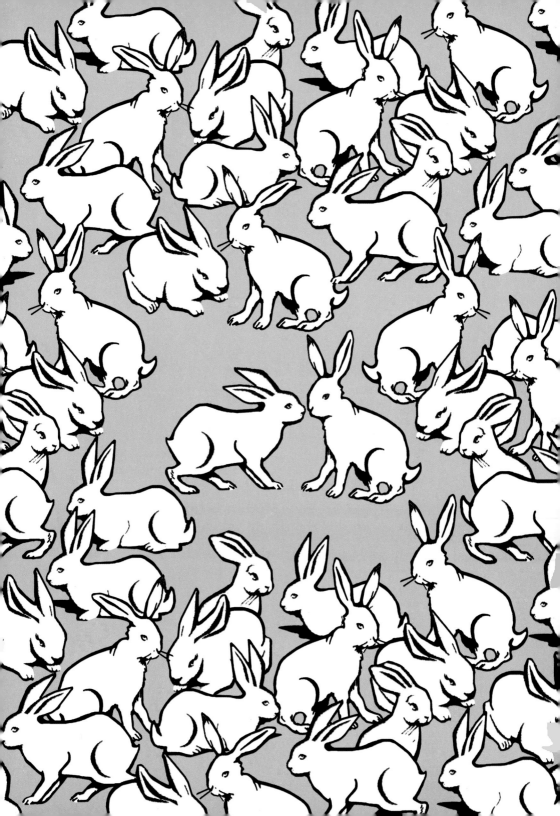

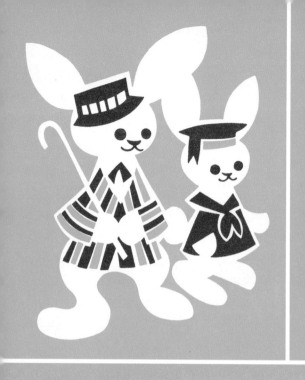
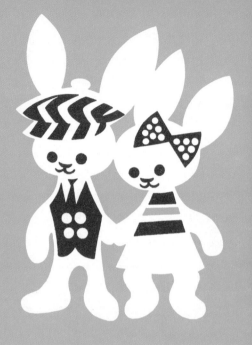
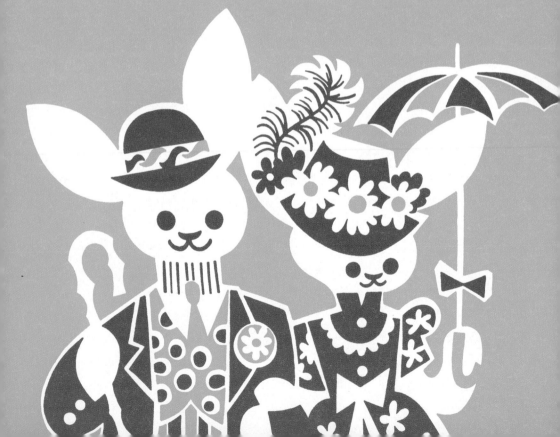

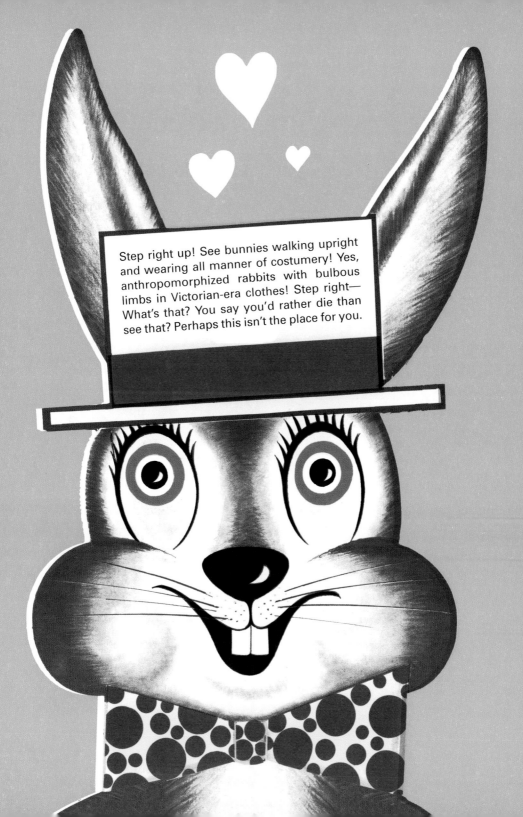

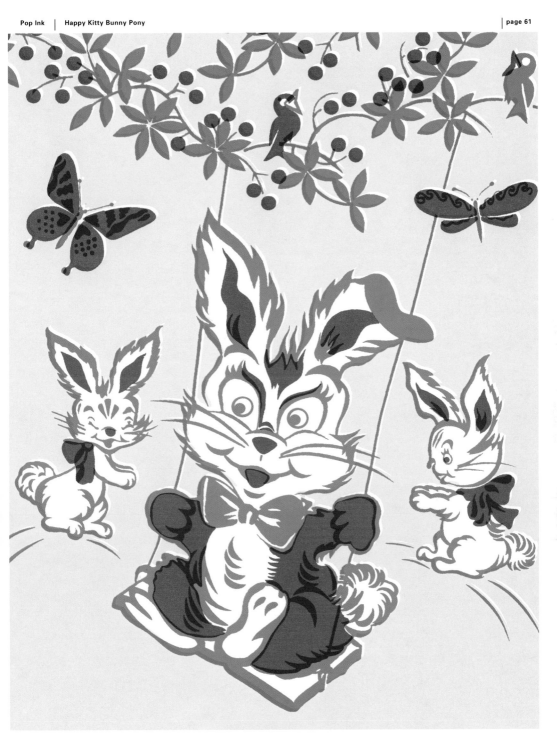

A cheerful, shaggy bunny having a Sunday swing with friends? Or a gullible rabbit caught in an ambush, about to be lit on fire and left to die by his two arch-enemies? It's not clear . . .

Looking for new wallpaper? How about a pattern featuring insane rabbits wearing bad wigs?

Yes, rabbits have large front teeth, but this fellow's overbite will kill him if he doesn't get help.

OLDEST ONE IN THE BOOK

The beloved rabbit-out-of-the-hat gag. Why a rabbit? Why a hat? Why a sinister man with distasteful facial hair? The answer is simple: The trick references a British woman named Mary Toft who, in 1726, gained fame by claiming to have given birth to a litter of rabbits. (That she could gain fame from this is a stinging indictment of 1726 England. But hey, if we got a good trick out of the deal, why not forgive and forget.)

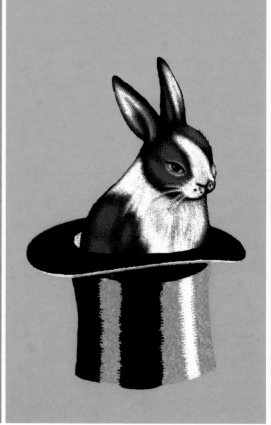

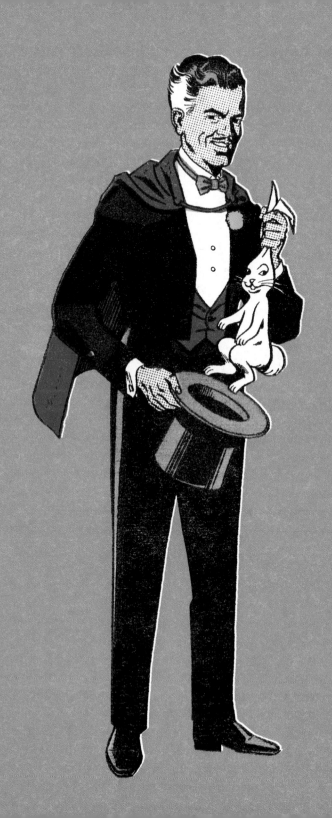

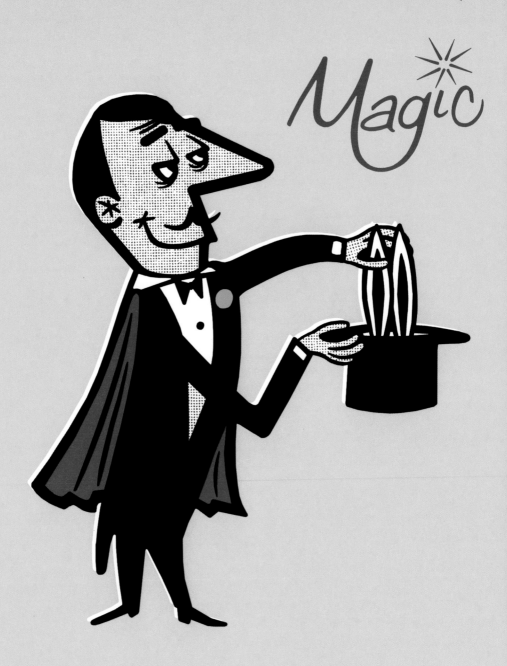

You ask, just how is the rabbit-from-the-hat trick accomplished? Very simply. A stubby-legged chap with one eye on the side of his nose puts on a cape and jams two ears of corn into his hat.

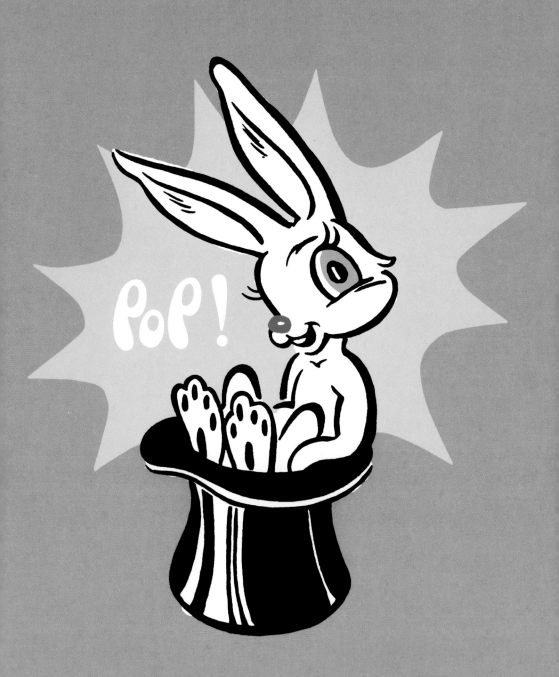

After a brief period, a small explosion occurs and the corn is magically transformed into a rabbit, albeit a slightly stunned, singed rabbit who may or may not relieve himself right there in the hat.

Want good luck? Cut off the paw of a furry rodent, mummify it, place a cap on the end of it, thread a chain through it, and put it on your key chain. The good luck will just roll in.

Lucky

SEVEN

7

EASTER BUNNY
This familiar symbol originated in Germany where children would build a nest for what they called the "Oschter Haws," in hopes he would lay a batch of colored eggs. That German children were so confused about biology does not speak well of the German education system. To all you German children out there, rabbits are mammals, which means they give birth to live young. No eggs involved. Perhaps you were confusing him with the Easter Duckbill Platypus.

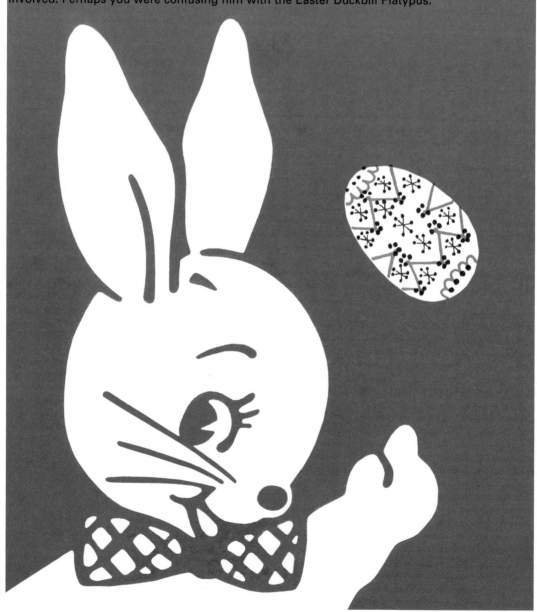

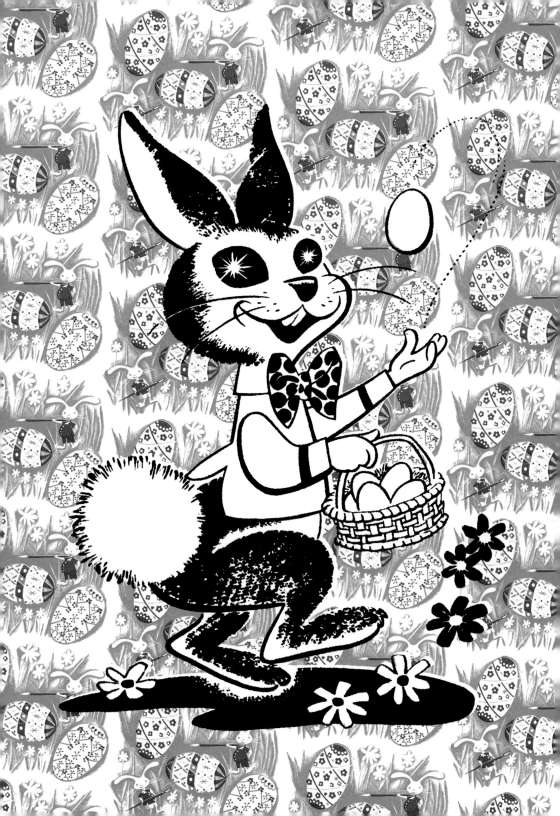

Since rabbits are mammals, where do they get those eggs? Well, late at night, armies of ferrets, who are in the pay of the Easter Bunny, swarm into chicken houses everywhere and steal as many eggs as they can. The eggs are then trucked to a secret factory where they are painted by low-paid woodland creatures. When completed, they are trucked to the Easter Bunny for distribution.

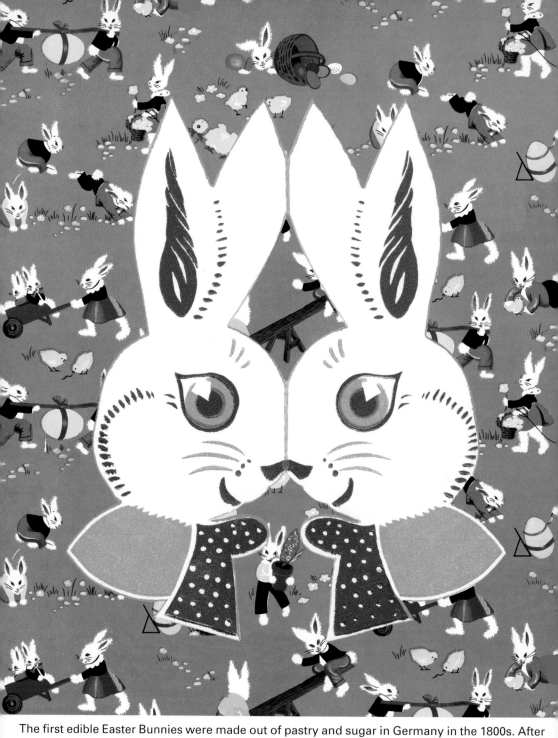

The first edible Easter Bunnies were made out of pastry and sugar in Germany in the 1800s. After 150 years of eating pastry-based Easter Bunnies, children rioted, demanding their bunnies be made of chocolate instead. Terrified adults complied. A kid/adult truce holds . . . for now.

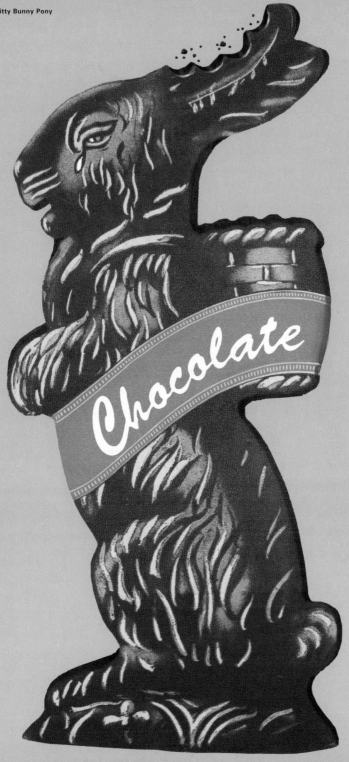

PONY

What exactly is a pony? Is it simply a small horse, or do ponies possess some elusive quality, some magical and imperceptible trait that sets them apart and makes them something very special? No, a pony's just a short horse. Anything under 14 hands (56 inches) is considered a pony. Feelings of inferiority often lead ponies to show up at children's birthday parties where they wander around looking pathetic until someone takes pity and accepts one of their slow and, frankly, lame rides. Some ponies have such severe "Short Man's Disease" that they take karate classes, buy motorcycles, and wear horseshoes with lifts in them.

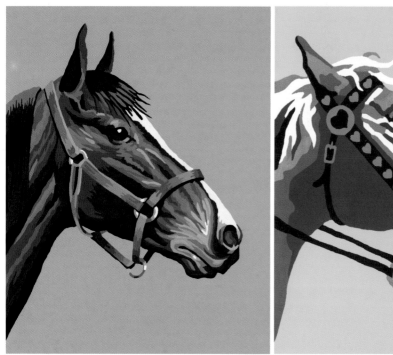

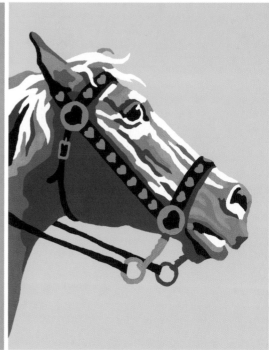

Look at those beautiful, liquid eyes, brimming with intelligence. That regal mane. That long, noble face, with its huge teeth set in a powerful jaw, capable of biting clean through human tissue.

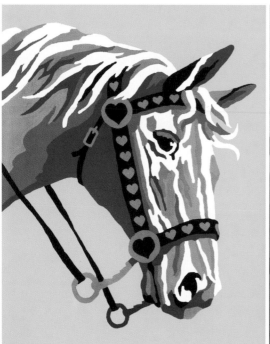

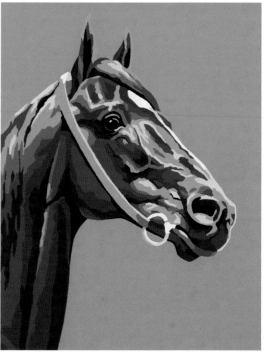

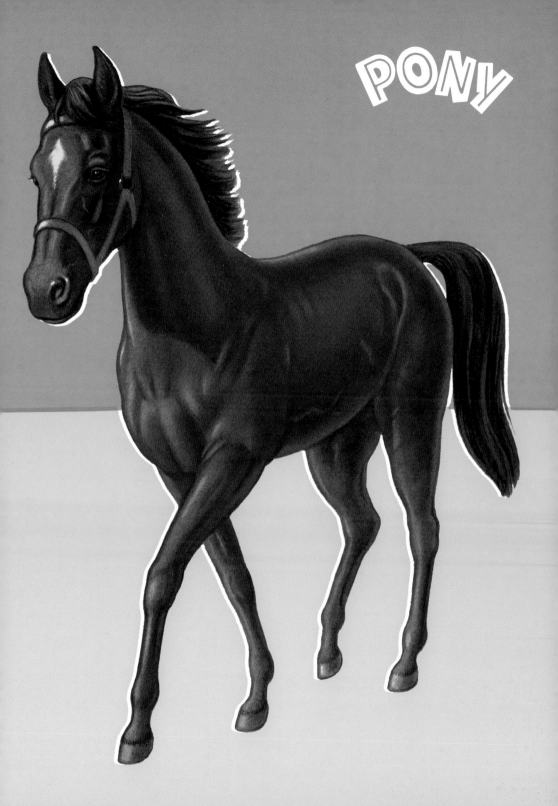

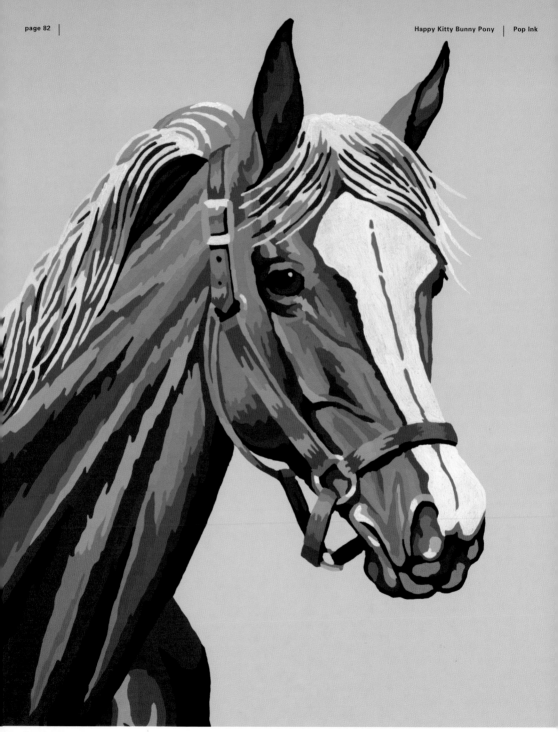

Ponies scare easily. If you open an umbrella near a pony, it is likely to startle and stomp you to death. Ponies are far less enchanting when you are beneath them, being crushed by their hooves.

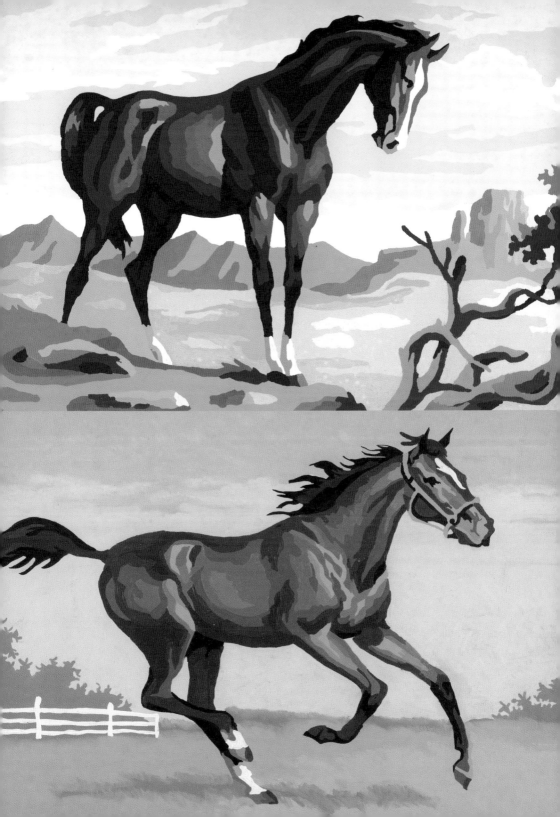

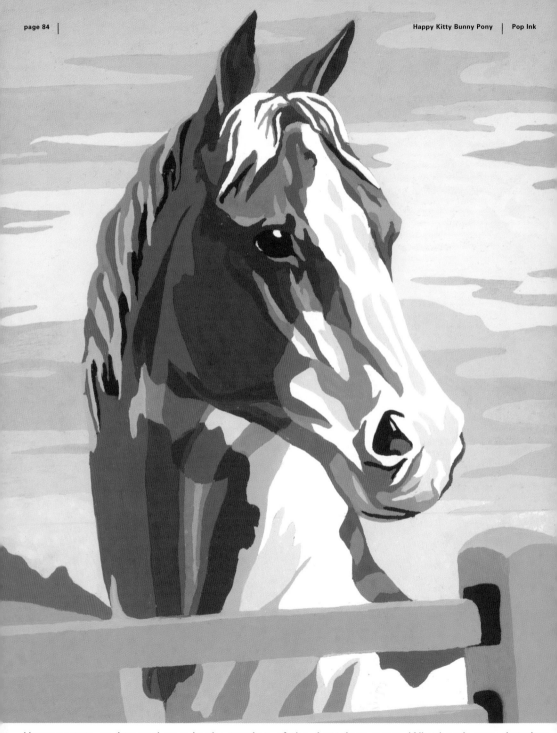

Horses were an integral part in the taming of the American west. Whether it was drawing wagons across the Great Plains or helping to transport mail for the pony express—horses did it all.

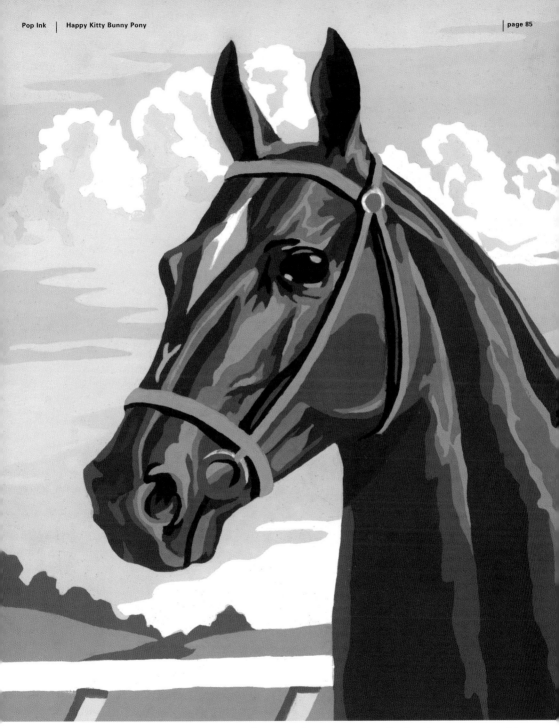

Not that they ever got paid for it. (They made several attempts to unionize, but never got things off the ground. Their lack of opposable thumbs made it difficult to sign the proper forms.)

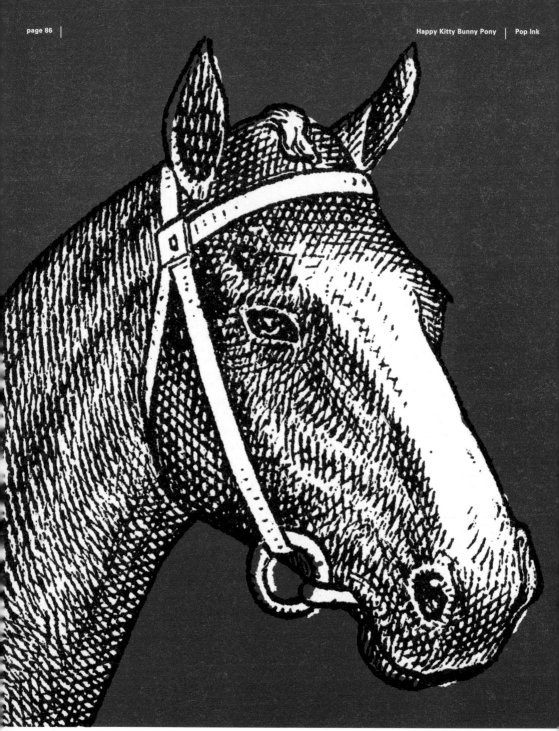

Horses are notoriously hard to draw. Their musculature is complex; their facial features intricate. If you're having trouble, just draw a dog with big nostrils and make its teeth less sharp.

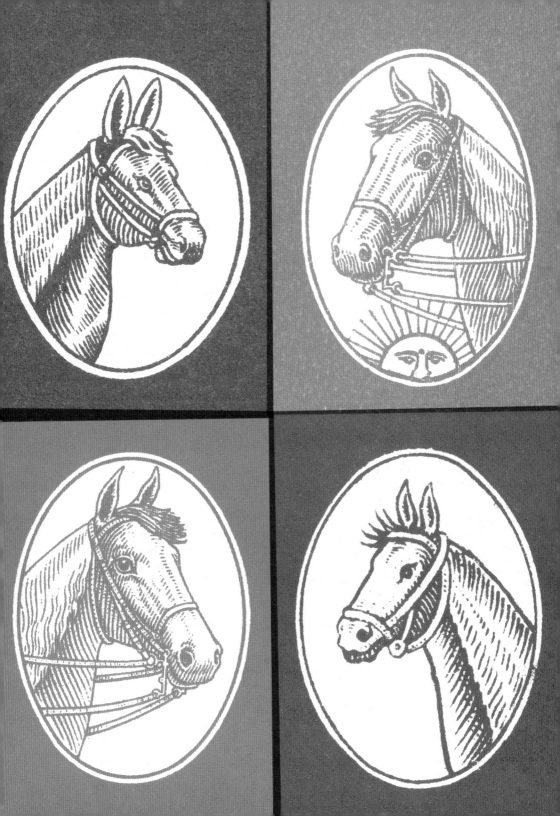

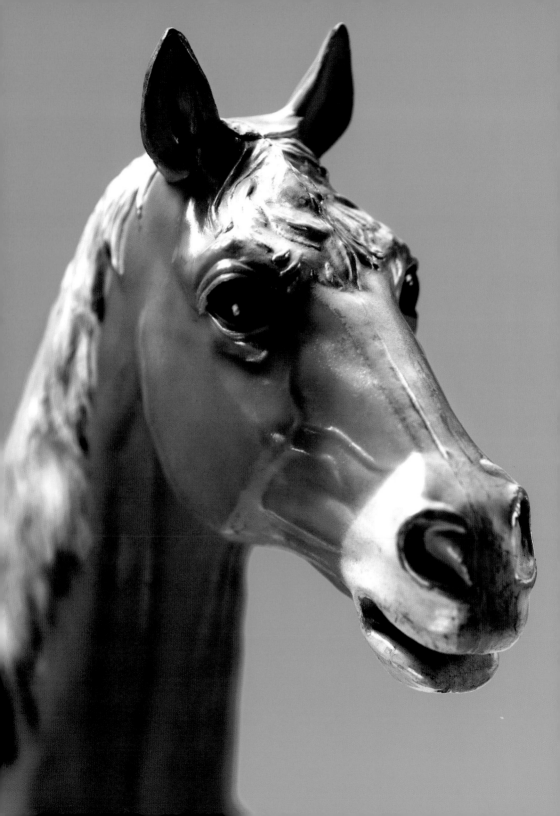

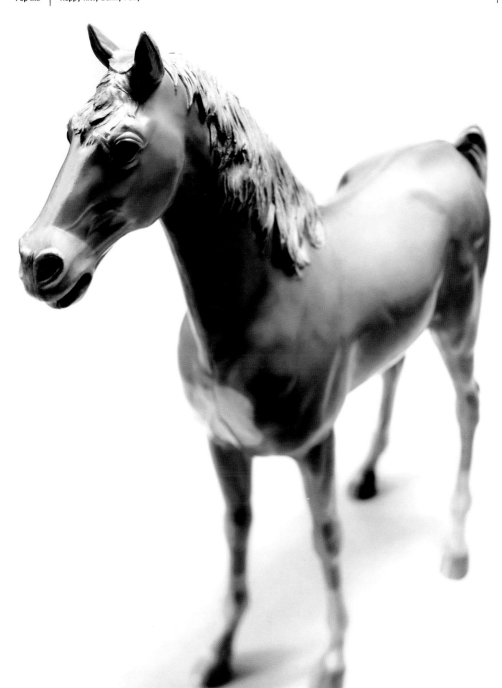

Most people have played with toy horses. Hopefully during childhood and probably because toy horses make such versatile playthings. You can make them walk, trot, canter, gallop. You can pick them up, maybe set them back down . . . well, that's about it. But it's fun!

Tradition holds that if a horseshoe is nailed to the barn, open side down, luck will flow out onto anyone nearby. (Those horses that are bridled, made to pull a plow, and have a whip cracking in their ear all day seem, however, not to have benefited from that luck.)

Ah, the traditional English riding gear, what with its derbies, jodhpurs, paddock boots, riding breeches, and chap pants . . . What the hell is up with the English, anyway?

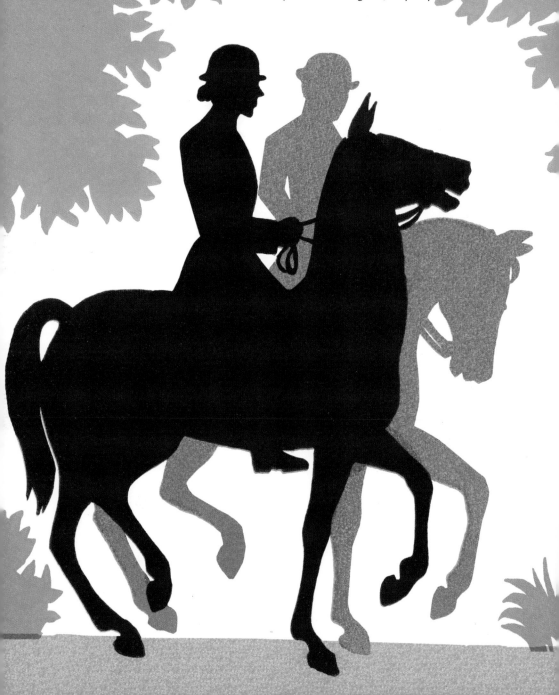

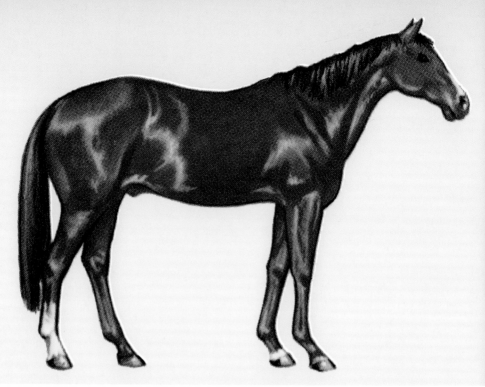

There are as many kinds of horses as there are stars in the sky: buckskins, paints, and bays.

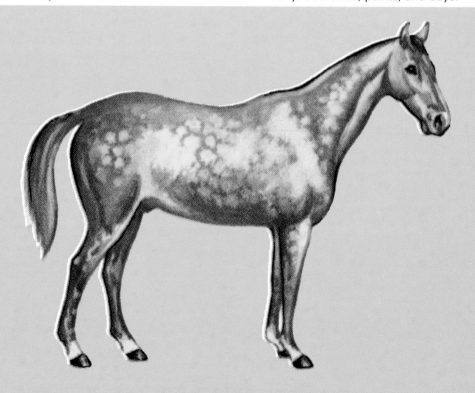

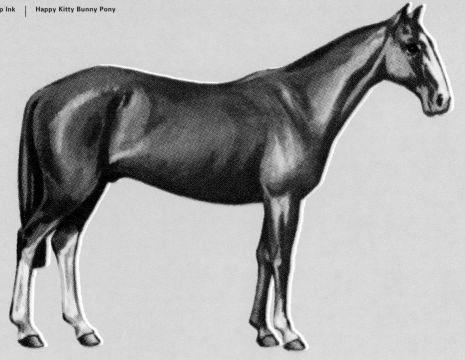

Get past the color variations, though, and they're all pretty much the same. Seen one, seen 'em all.

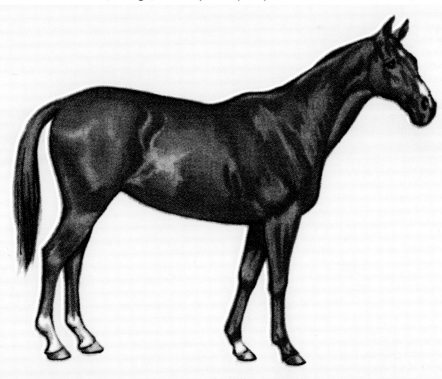

PRETTY PONY

There is no animal that doesn't benefit from getting dolled up in a colorful hat, having its eyelashes thickened and curled, or having makeup applied to its eyes and lips. And no animal doesn't benefit from prancing around making googly eyes and looking coy. Horses are no exception. (The only exception would be a turtle. There is nothing you can do with a turtle. They are hopelessly ugly, and, quite frankly, there's nothing worse than watching a turtle trying to be coy.)

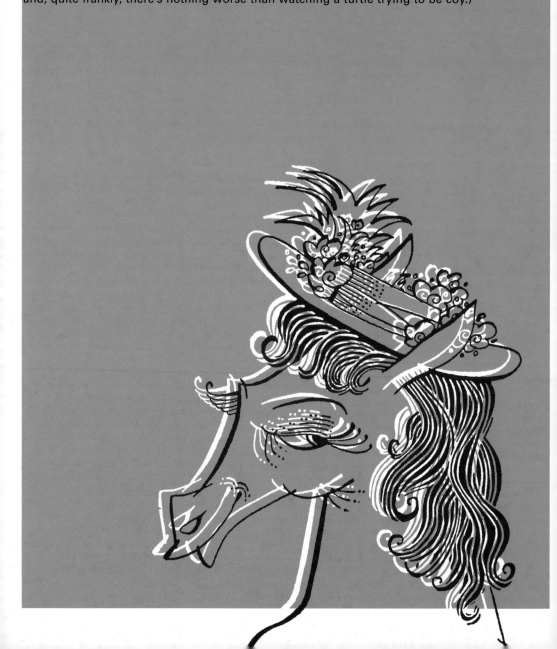

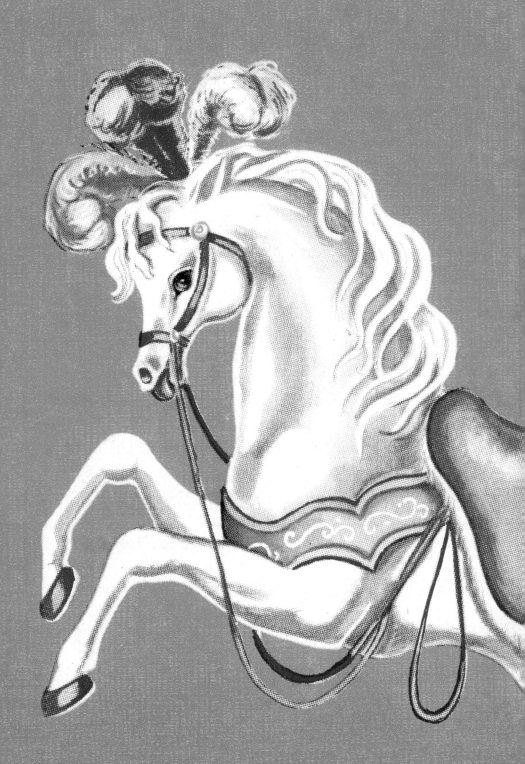

the

UNICORN

The mystical, magical, whimsical unicorn, creature of legend and lore, was first mentioned by Herodotus, who in the third century BC wrote of a "horned ass." Later, the Greek physician Ctesias traveled to the East and brought back stories of the "wild ass of India." Either unicorns were common in the ancient world, or those people were obsessed with asses. Knowing what we know about the ancient world, the latter seems more likely.

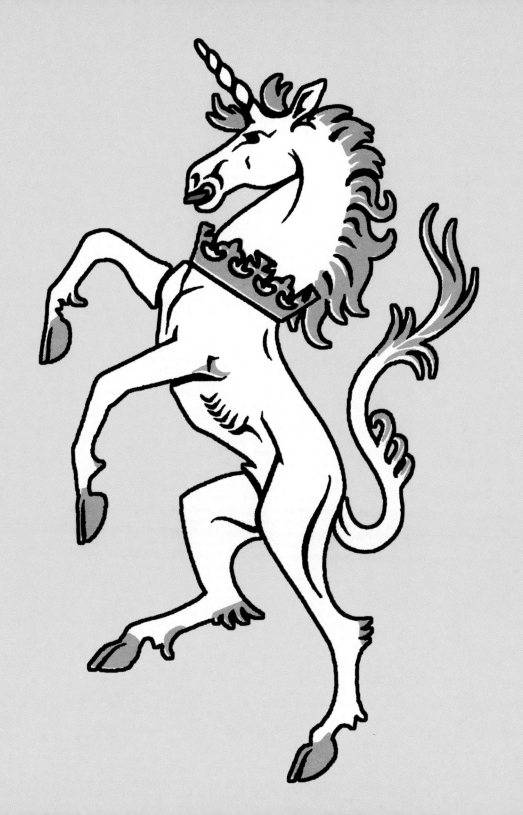

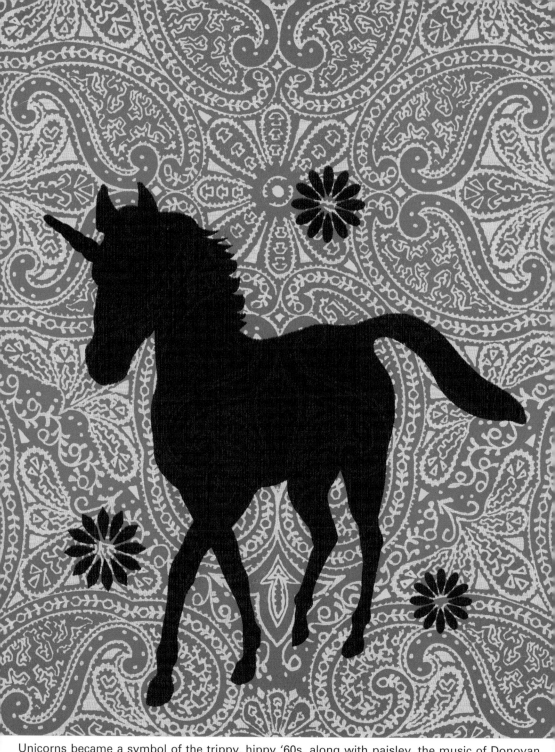

Unicorns became a symbol of the trippy, hippy '60s, along with paisley, the music of Donovan, garishly painted VW microbuses, questionable hygiene, and insane levels of hallucinogenic drug use.

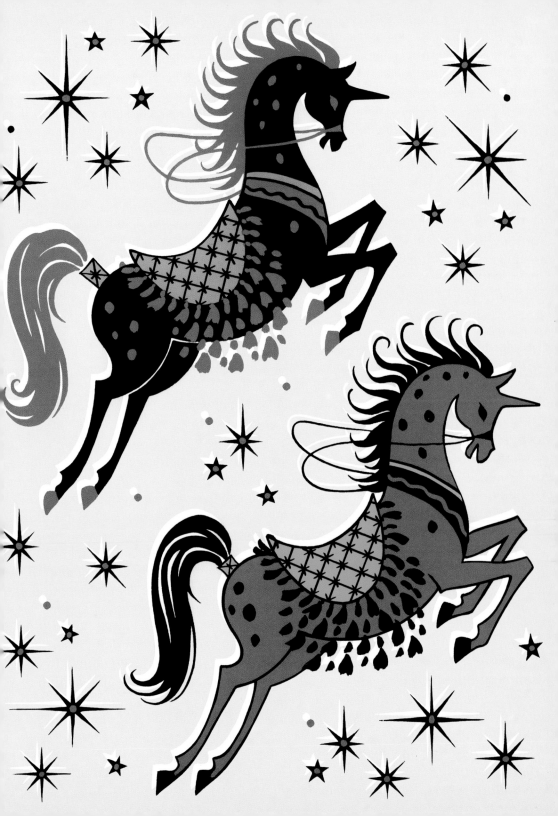

According to legend, even the deadliest poison will be neutralized if you drink it from the horn of a unicorn. While fascinating, this fact is of little use, because really, how many times do people offer you a glass

of poison, and after doing so allow you to transfer it to your own unicorn horn? Beyond that, it should be pointed out that unicorns do not exist, which pretty much kills this helpful tip right out of the gate.

BARNYARD BUDDIES

Old McDonald had a farm, and on that farm he had lots of adorable barnyard buddies! Including this fat pig, who is seeing in another trainload of whatever food it is that's making him morbidly obese. Whatever it is, he should cancel all future orders, get on a low-carb diet, and start a regimen of a cholesterol-lowering drug such as Lipitor. It might also help if he stopped playing with trains, went outside, and tossed a ball around with the neighborhood farm animals now and then. If they'll have him, of course.

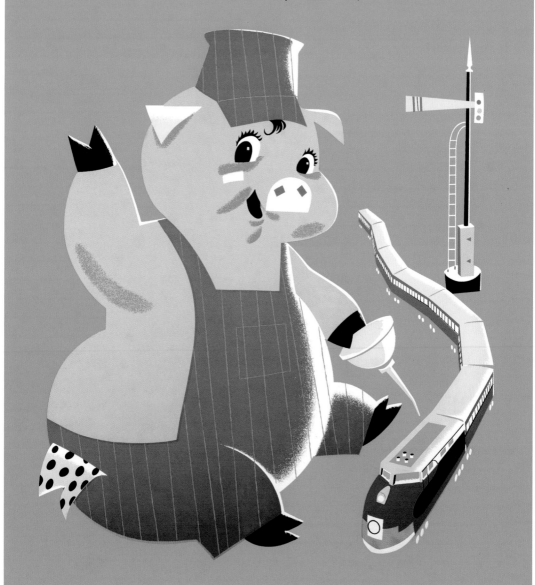

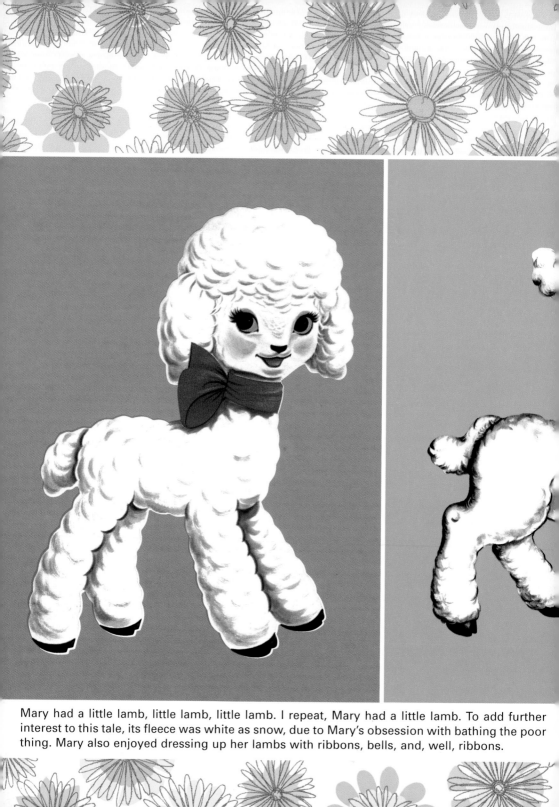

Mary had a little lamb, little lamb, little lamb. I repeat, Mary had a little lamb. To add further interest to this tale, its fleece was white as snow, due to Mary's obsession with bathing the poor thing. Mary also enjoyed dressing up her lambs with ribbons, bells, and, well, ribbons.

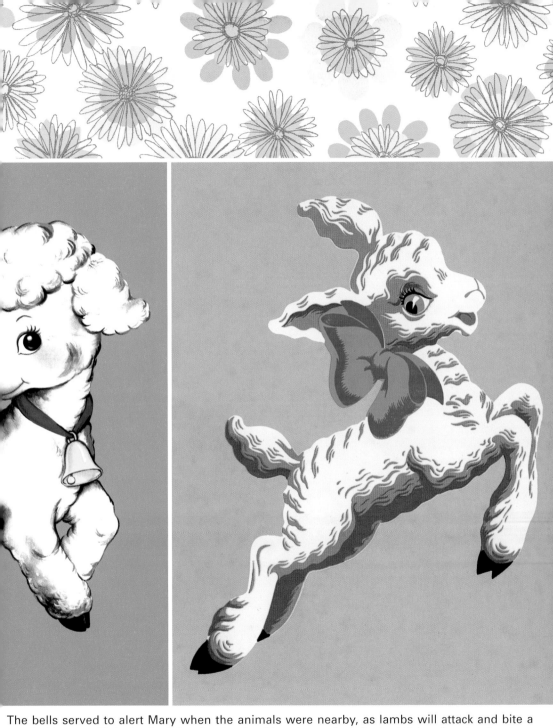

The bells served to alert Mary when the animals were nearby, as lambs will attack and bite a startled human. To help discipline her lambs, Mary kept a jar of mint jelly on hand to let them know that it works both ways—that roasting little lambykins would be nooo problem at all.

CHICKY DUCKY

What's fuzzy, chubby, chirpy, and cute? No, not Elton John. Chicks! Newly hatched chicks are simply one of the cutest things in the entire world. For about 2 days. Then it's just eating and pooping and growing and breeding. In fact, there are more chickens in the world than there are people. 650 million chickens in America alone . . . watching, waiting, plotting. Unless you think all the chirping is just chirping. But go ahead, ignore the obvious signs. When you're buried in an avalanche of yellow puffballs, each one pecking and pecking viciously at your eyes and vitals with murderous intent, don't come crying to me.

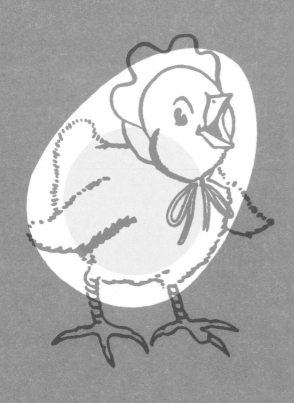

As cute as he is, and that's mighty cute, one cannot help but wonder how this duck manages to squeeze into those tiny shorts. One also must wonder if that's his ship down the shore. And if so, it gives rise to the unsettling thought that there's an armada of baby ducks out there, somewhere. If so, a few AGM-84 Harpoon missiles could certainly solve that.

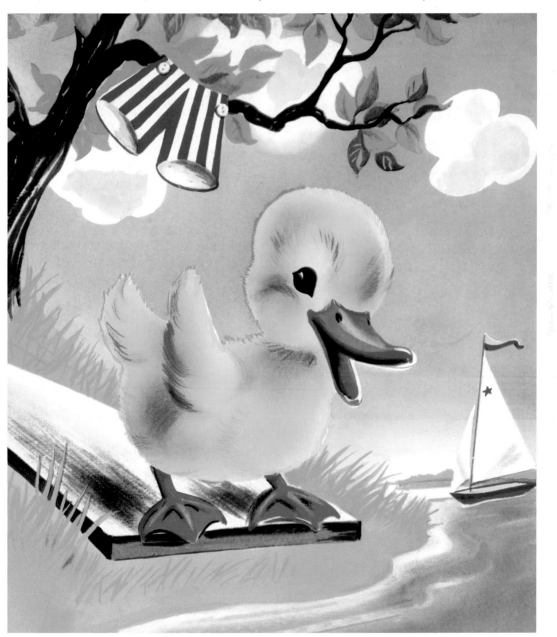

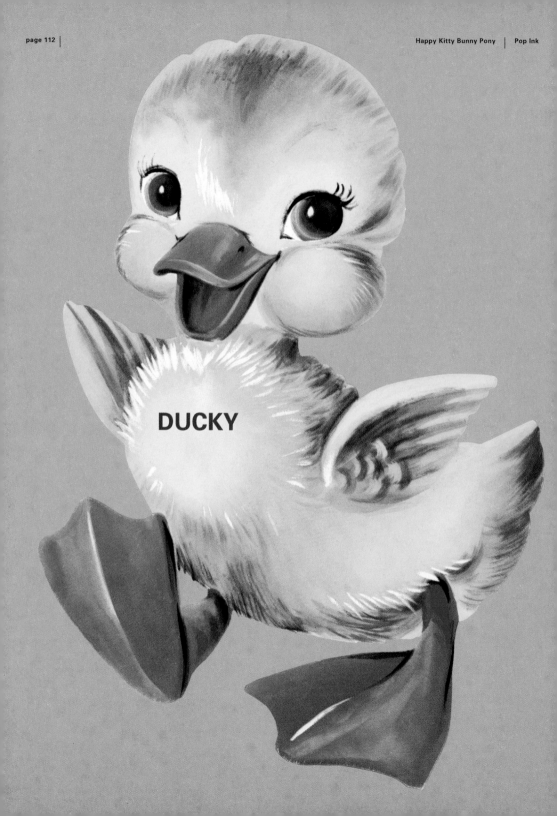

DUCKY

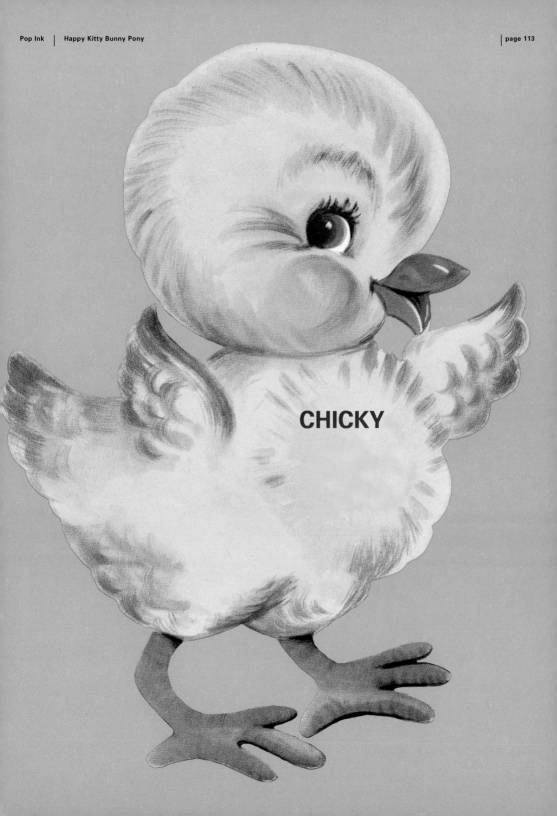

CHICKY

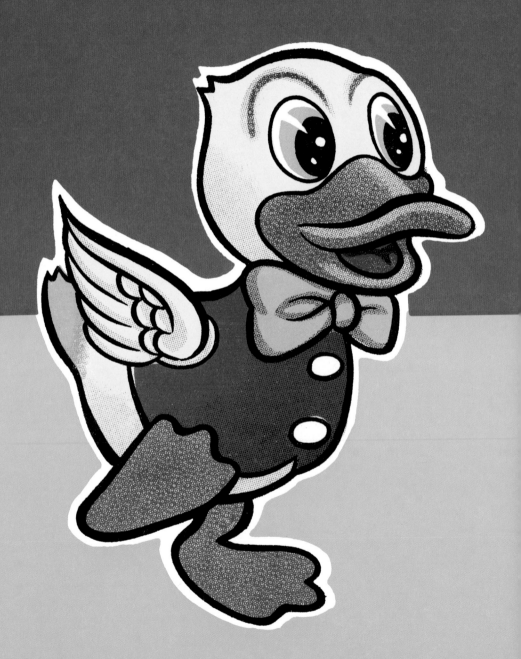

Vests and bow ties went out a long time ago but no one seemed to tell this poor dope. Someone should rub him with a little salt and pepper and roast him right out of his misery.

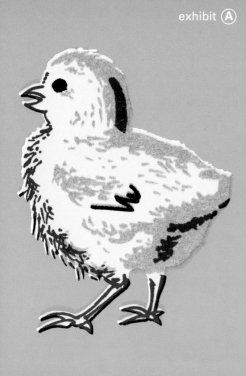

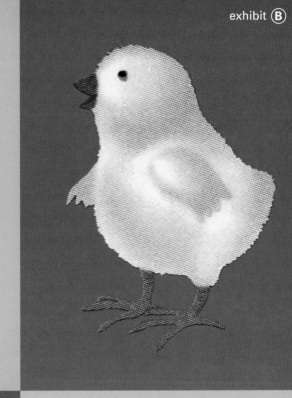

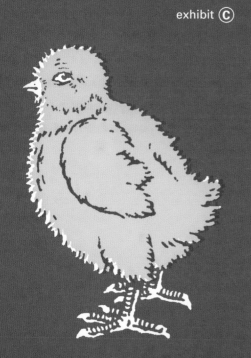

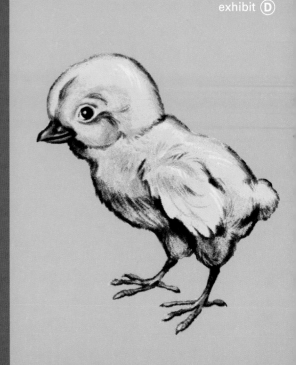

WOODLAND CREATURES
Wahoo! This little fellow's having himself a good ole time. But my goodness he's large. Why in the devil did he think that hat would look good on his massive pumpkin head? Why didn't he go to a reputable haberdasher who would have picked him out a nice size 453 Stetson? And would someone please coax him off that rocking horse? It's an antique and if he rocks one more time, it's going to splinter into a thousand worthless pieces!

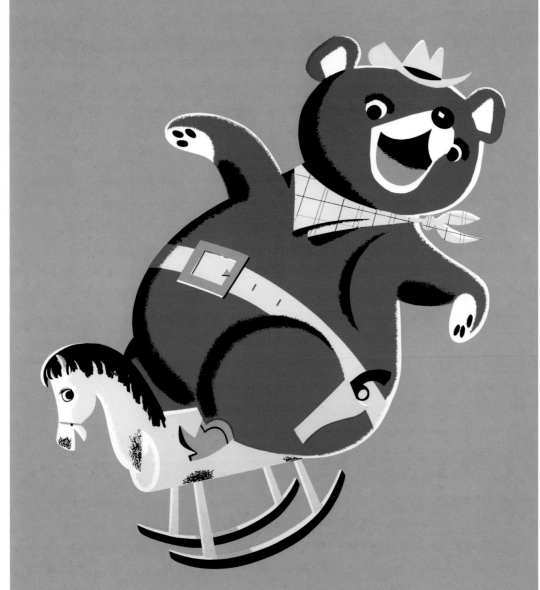

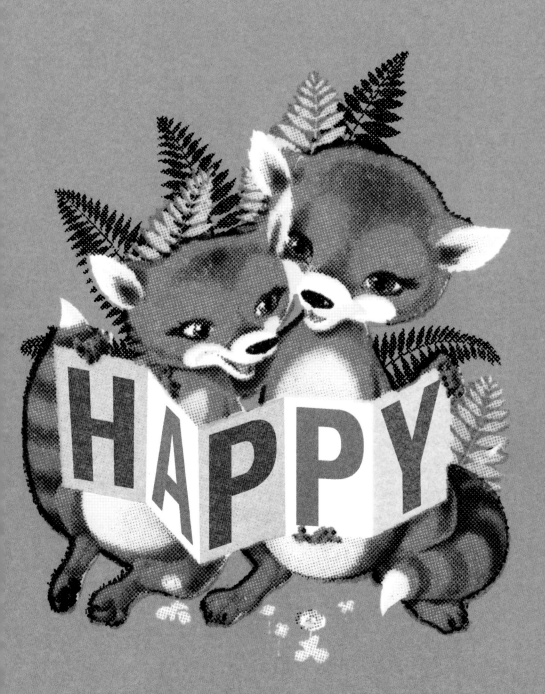

Baby's first cave paintings! Either that or real animals were daubed with ink and thrown against a wall. An activity, by the way, NOT recommended by the ASPCA, or OSHA for that matter.

The gypsum wallboard might fragment, sending bits and pieces into the thrower's eyes. So if you're going to do any animal throwing, wear eye protection and throw only small, soft animals.

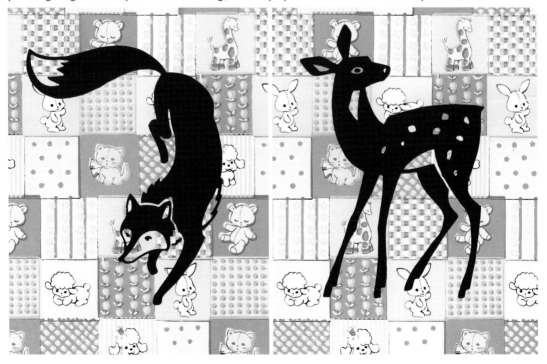

Babes in the Woods

The woodland creatures are our friends, for the most part. But it does get tiresome when you're out in your best Sunday outfit and rodents are climbing all over your dress, the deer—which are tick magnets—are leaning up against you, and the notoriously dirty birds are strafing you, possibly even inadvertently dropping loads on your back. Frankly, these friends would be so much cuter if they stayed a little farther away.

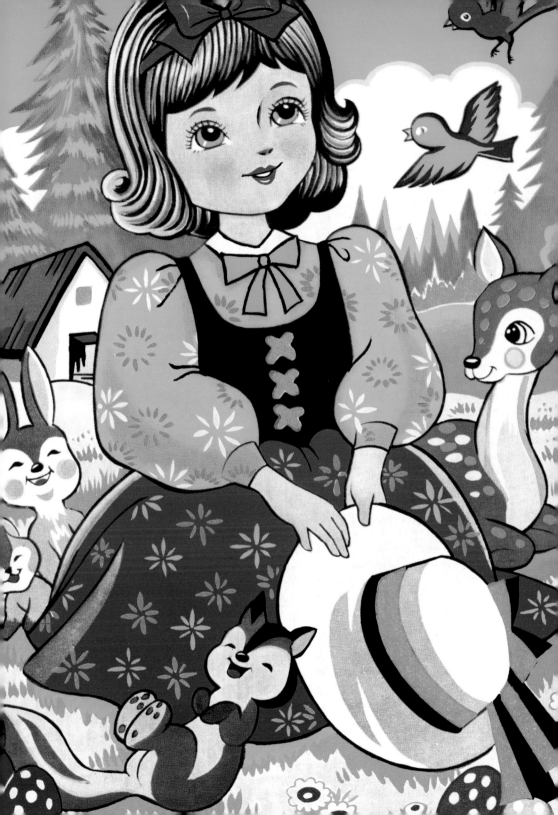

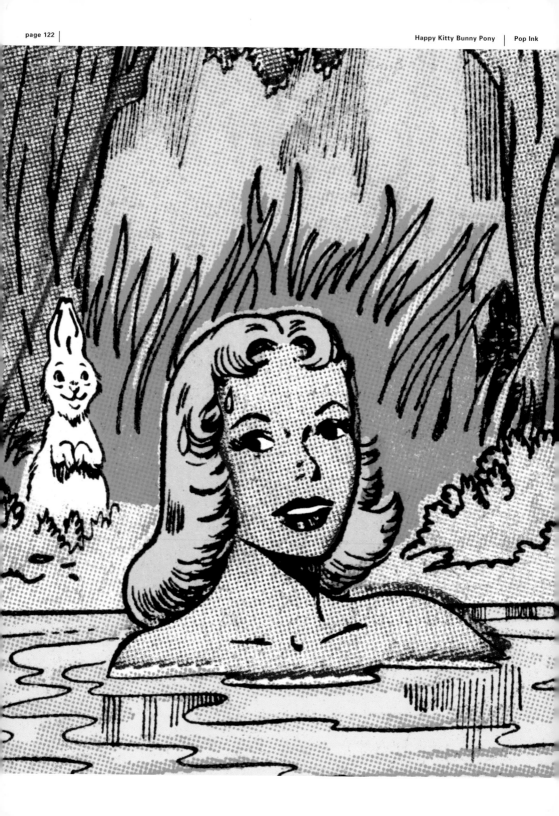

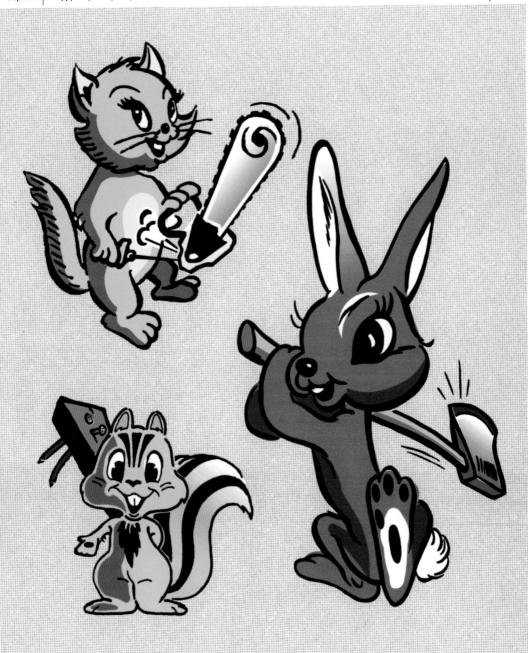

Because of their universal appeal, woodland creatures have provided inspiration for many beloved cartoon characters: Daffy Duck, Woody Woodpecker, and, pictured above, Cameron the Chainsaw Wielding Cat, Randy the Axe-Murdering Rabbit, and of course, Chester the 13-Striped Ground Squirrel Who Will Distract You and Then Drive a 16-Penny Nail Into the Back of Your Neck. (opposite page: Don, the Fat Peeping Tom Whose Name Is on File with the Police.)

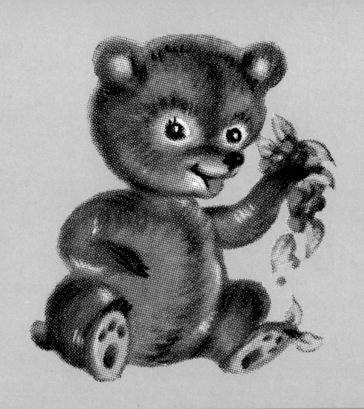
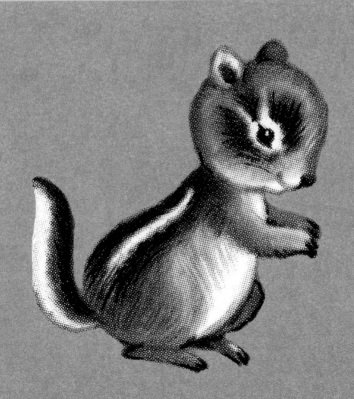

Bears are omnivorous. Their scat has been known to contain tin cans, motorcycle chains, scout badges, and even crushed hubcaps. These little fellows are playing a game of "Guess What I Ate?"

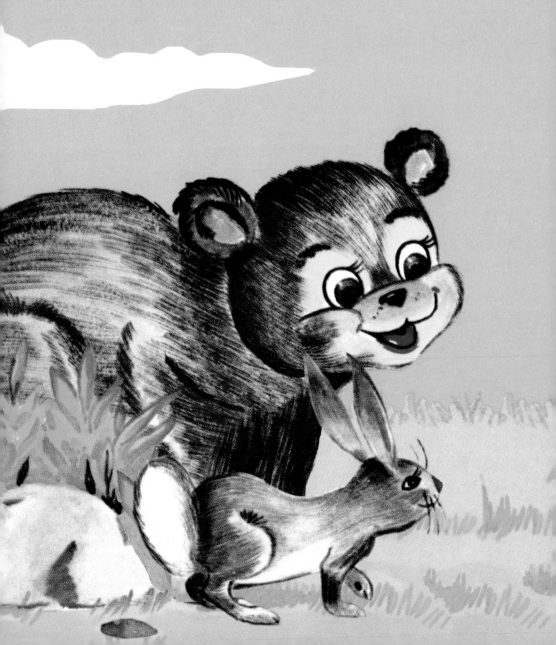

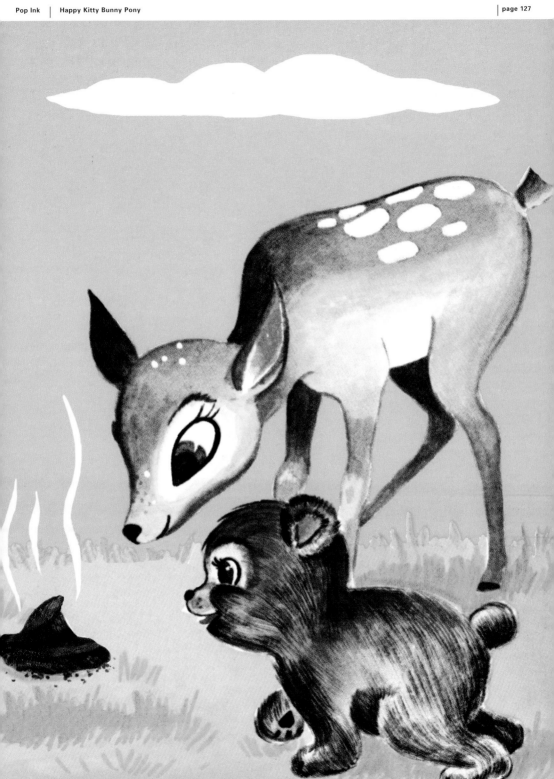

Jerome

Leonard

Esteban

Martha

What's this little fellow got in his paws? A can of commercial bear food? He doesn't really look like a bear, does he? He looks more like a panda, or perhaps a mouse. That's it: He's a panda mouse. So clearly he's holding a can of creamed corn, a panda mouse's favorite food!

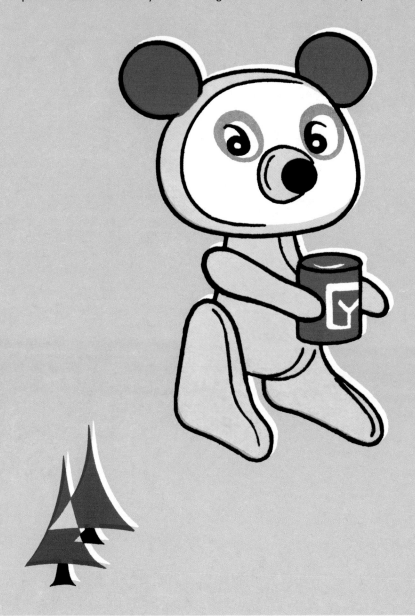

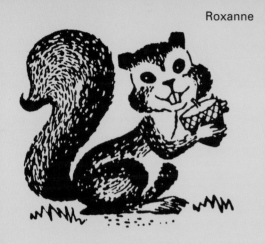

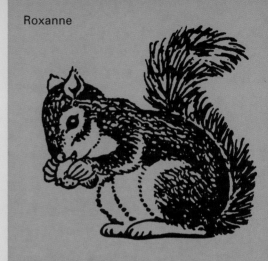

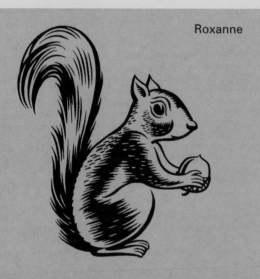

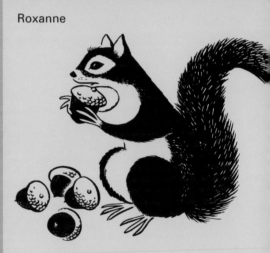

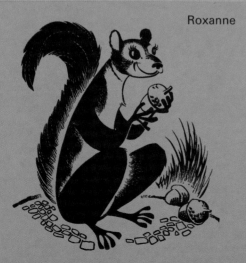

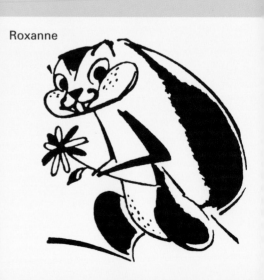

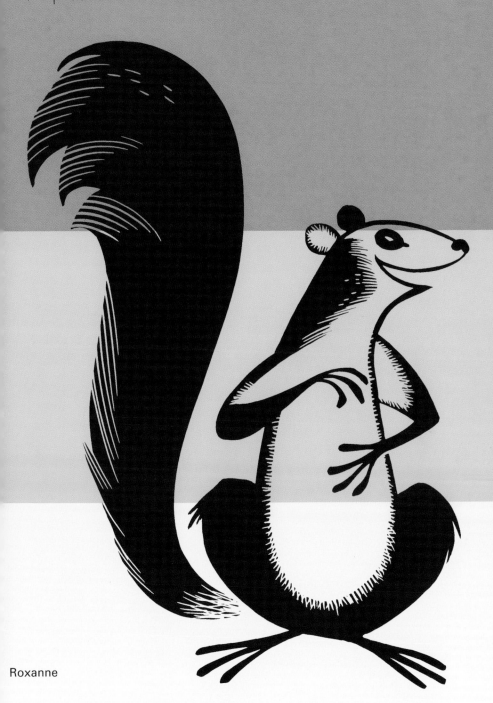

Roxanne

Yes, it's Roxanne, the shape-shifting squirrel. Roxanne can change at will from a chubby, cute, inquisitive squirrel, into an odd, psychotic, malnourished one–and back again!

ChipmunkFact®: A chipmunk's cheek pouches extend from the mouth to the shoulder, and they

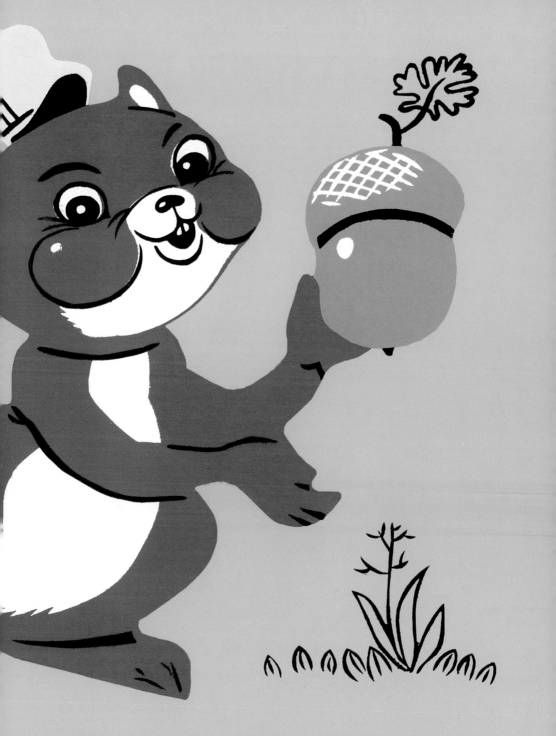

grow larger with age. A large, elderly chipmunk can store a 51-gram Salted Nut Roll in each cheek!

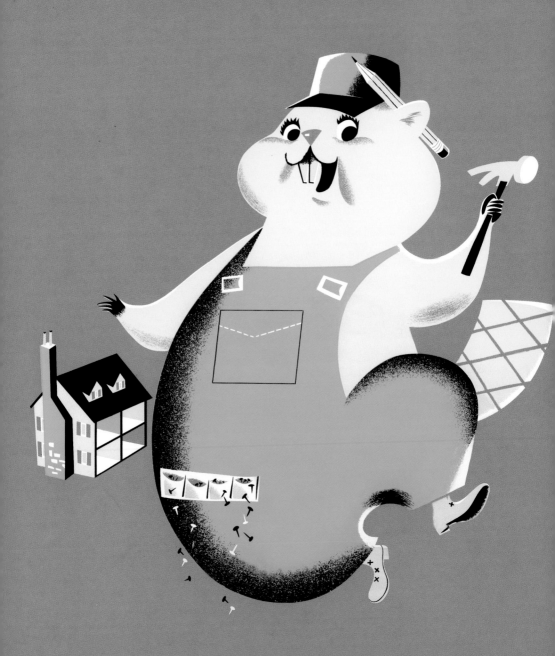

The beaver is North America's largest rodent. Specimens up to 90 pounds have been found—95 if you count their work boots, overalls, nails, hammer, and Fidel Castro hat.

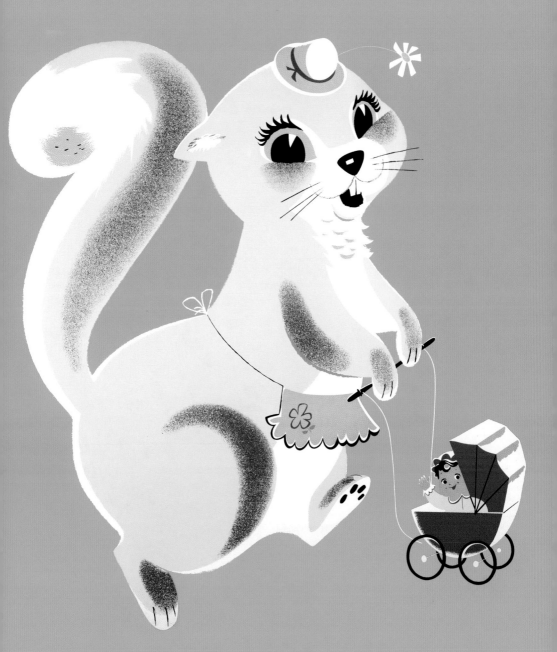

More than 48 percent of adult Americans fear being enslaved by a race of gigantic, female squirrels in hats who will push them around in monstrous strollers (down from 86 percent in 1971).

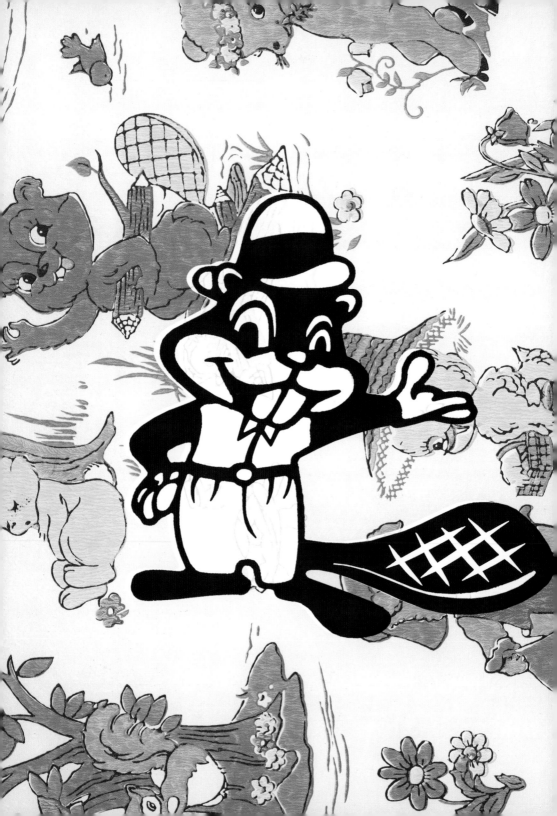

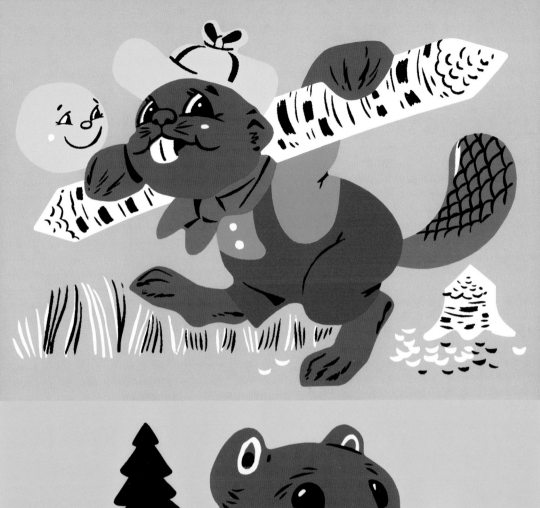

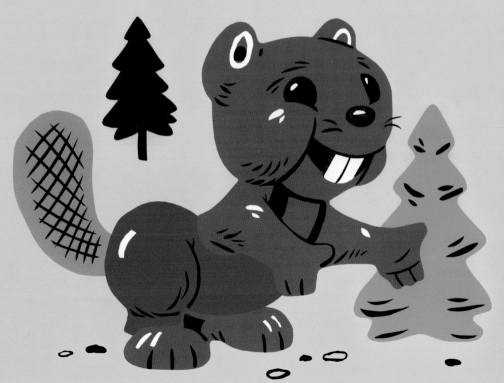

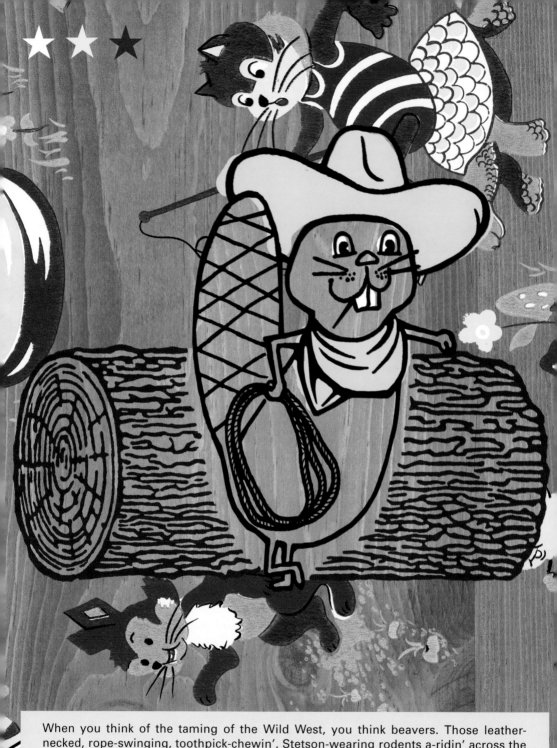

When you think of the taming of the Wild West, you think beavers. Those leather-necked, rope-swinging, toothpick-chewin', Stetson-wearing rodents a-ridin' across the plains and a slappin' their tails on the water if'n there's danger nearby. Don't you?

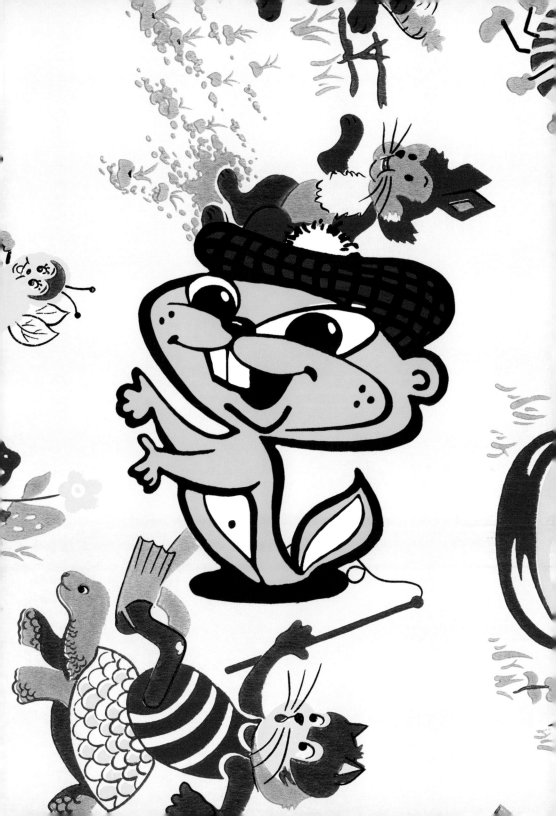

FRIEND OR DOE

The white-tailed deer is the most commonly hunted animal in the United States, and it is also one of the wiliest. It has an uncanny sense of smell. And hunters go to great lengths to hide their human scent, rubbing on apple juice, deer droppings, and even musky, sallow doe urine. During hunting season, they also let their beards grow, cease to shower, and live in small shacks eating only beans. Hunters are very lonely people. They are, however, armed and hungry. So during hunting season, it's best to dress in blaze orange, sound an air horn every few minutes, and never venture outside.

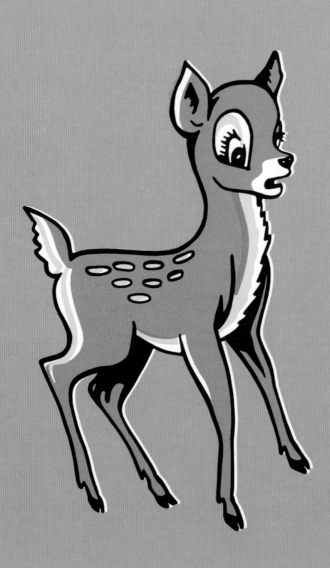

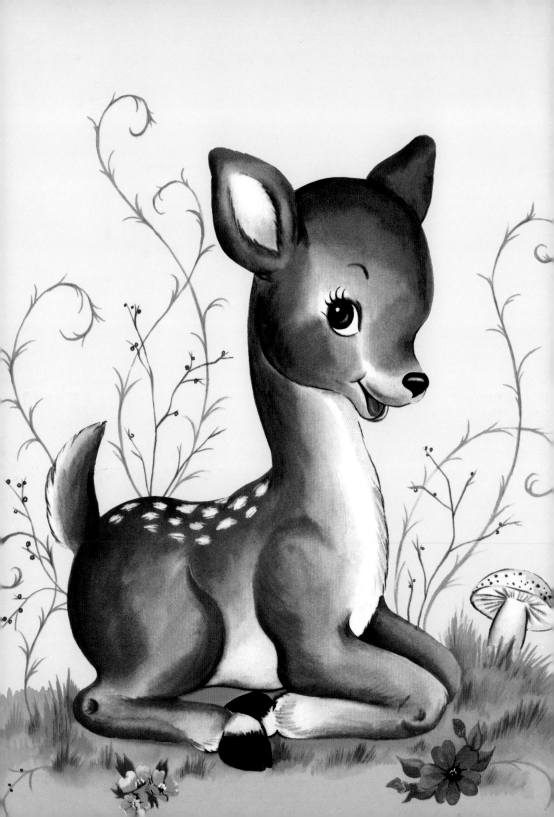

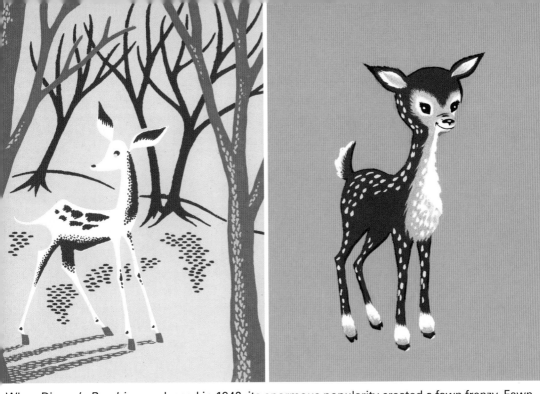

When Disney's *Bambi* was released in 1942, its enormous popularity created a fawn frenzy. Fawn costumes sold out all over the country, stuffed fawns became the de rigueur gift, "fawn" was the most requested color for car interiors, not to mention a popular baby name (even for boys!).

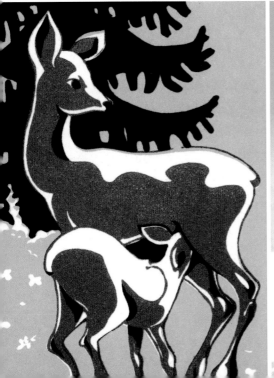

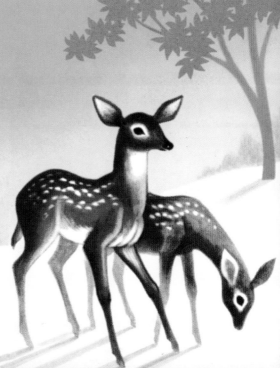

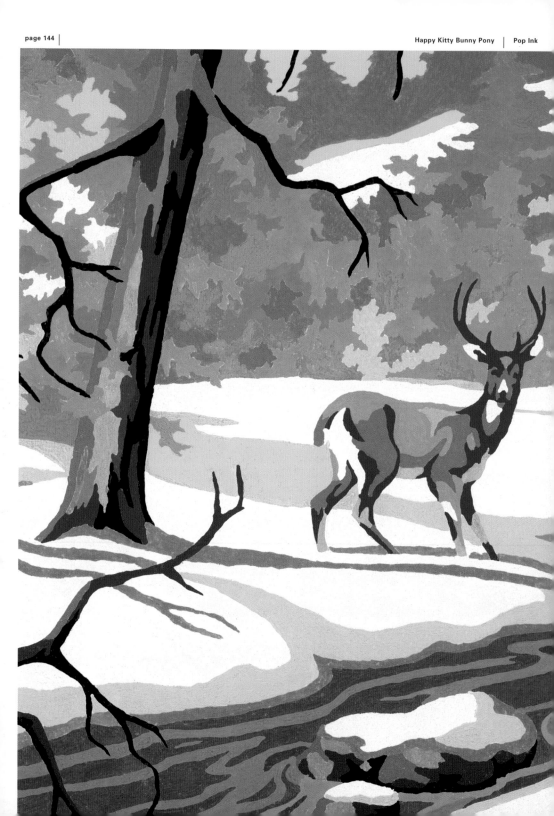

WILD+LIFE

To mark their territory, bucks rub their antlers on trees and shrubs. This practice also prepares them for the showy, shameless displays they put on during the mating season, wherein two competing bucks lock horns, push each other around and say, "C'mon—or are you too scared, man?" like seventh graders waiting for the teacher to break them up.

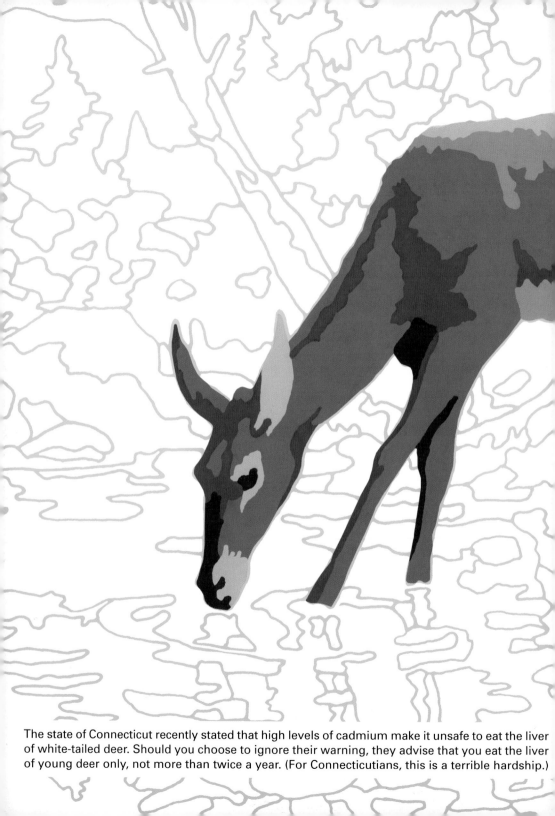

The state of Connecticut recently stated that high levels of cadmium make it unsafe to eat the liver of white-tailed deer. Should you choose to ignore their warning, they advise that you eat the liver of young deer only, not more than twice a year. (For Connecticutians, this is a terrible hardship.)

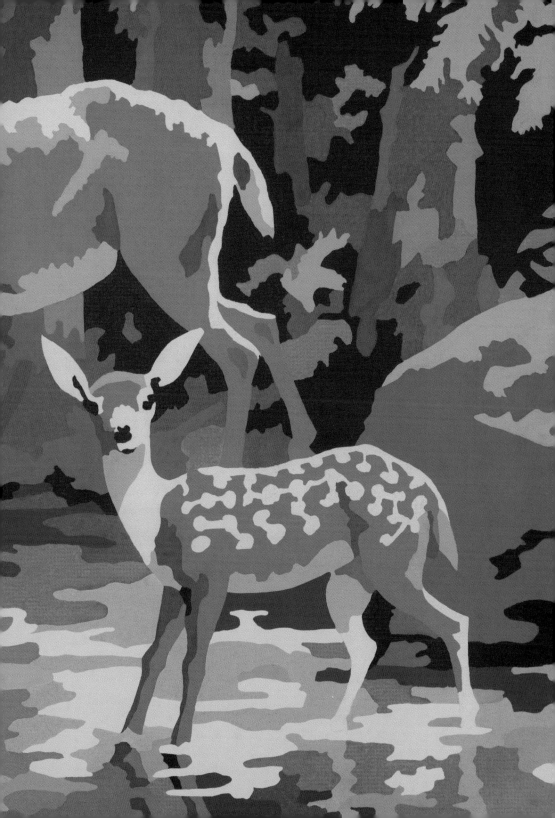

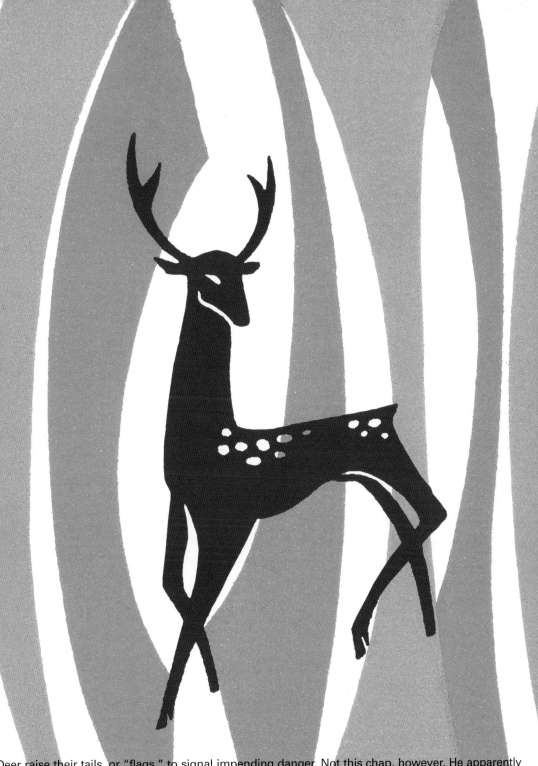

Deer raise their tails, or "flags," to signal impending danger. Not this chap, however. He apparently had his tail bobbed, probably for vanity reasons. It looks good, sure—but it just might get him killed!

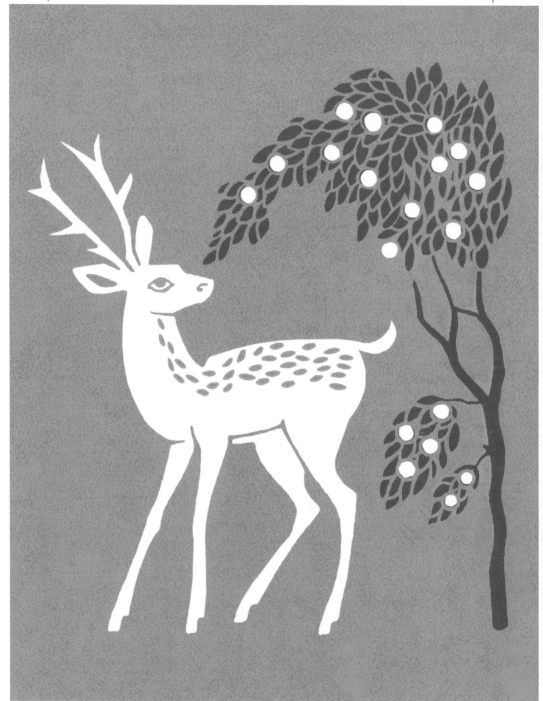

While humans enjoy eating deer, deer enjoy eating leaves, twigs, bark, and cultivated crops—

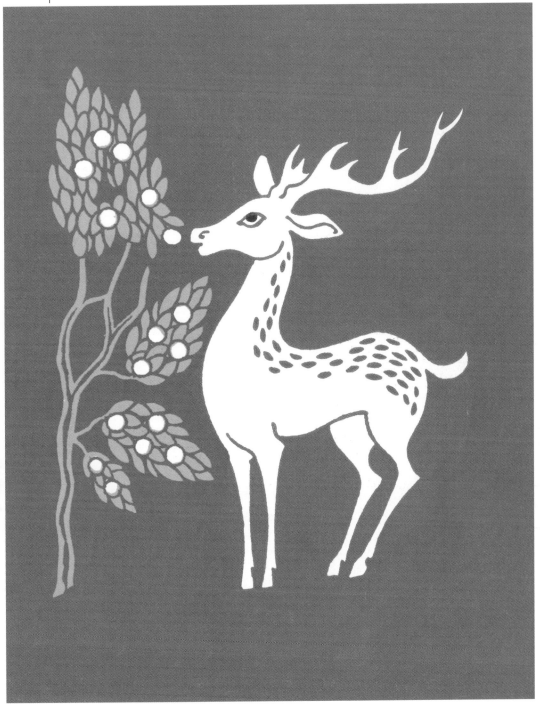

crops, it should be pointed out, that we humans cultivated. In other words, deer are dirty thieves.

To protect crops from hungry deer, some farmers install electric fences. Wily deer know how to

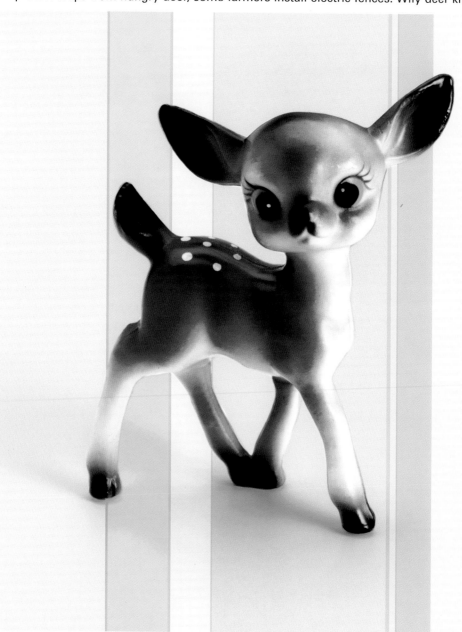

avoid these, so farmers will sometimes put in trip wires, motion detectors, and guided missiles.

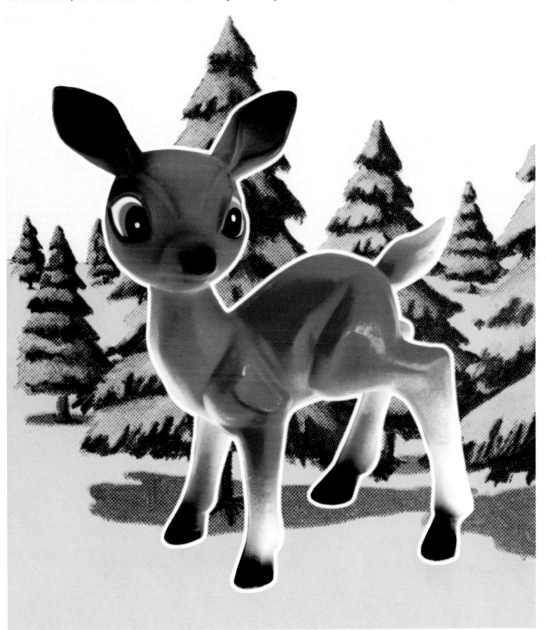

Doe

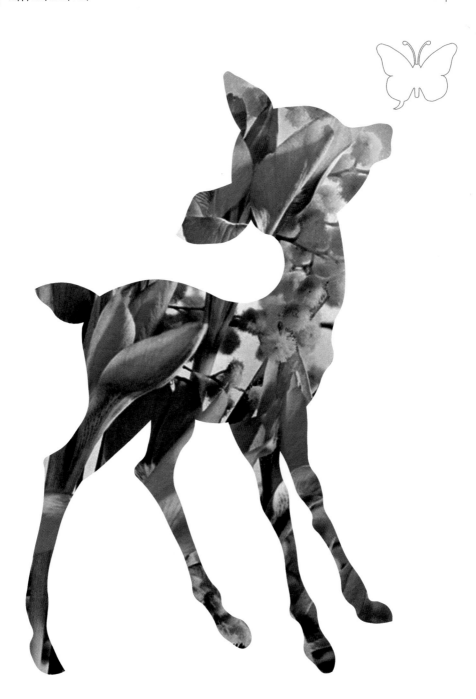

If you find a fawn, it's important that you not feed it anything other than water. Milk, soy products, commercial feed—anything else may be fatal. Be especially careful not to feed it a Philly cheese steak.

FURRY FRIENDS
Animals of all kinds are our friends and we owe them our love, kindness, and companionship. That's tough to keep in mind when you get a load of this oddball! He seems friendly, but looks unbalanced. Plus, you have to suspect he's the type who'll hang around you constantly and not take your strong hints that you'd rather he leave. He probably tells intensely personal stories about all the many times he's been rejected in his life, too, just to draw you in and and make it harder for you to dismiss him. If you see this guy coming, save yourself a lot of heartache—turn and run.

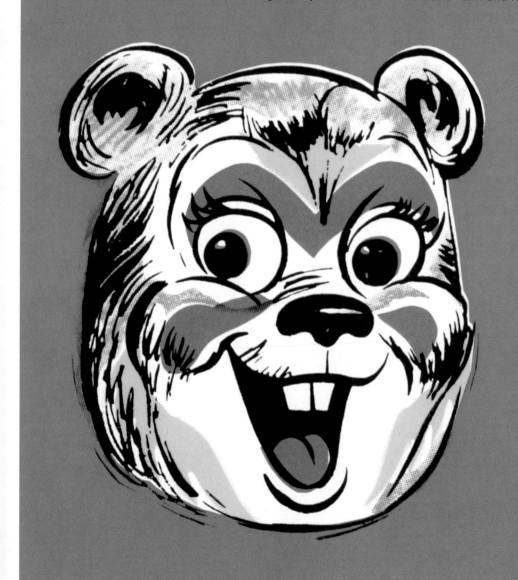

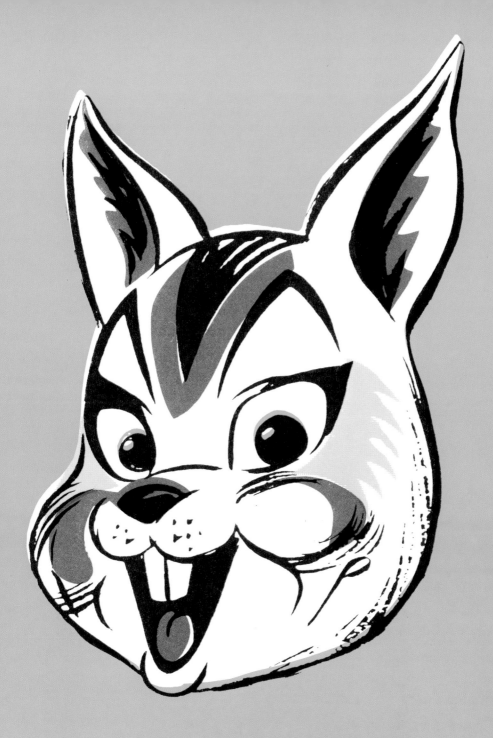

Smileage

In the real world, animals don't smile, nor do they frown. They show their displeasure or pleasure by either attacking you or not.

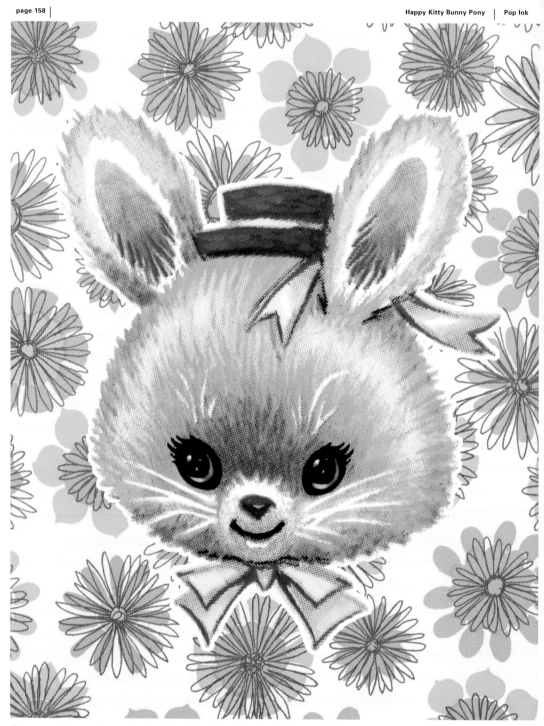

Apparently, cranium size is directly related to intelligence. This three-month-old bunny has an IQ of 409, speaks seventeen languages, and has written a very plausible "Unified Field Theory."

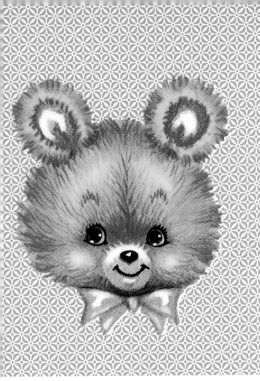

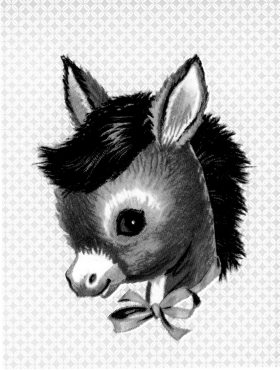

These baby animals are classmates at the Fuzzy Wuzzy Itty Bitty Cutesy Wootsy Montessori School. Amy, the kitty, and Barney, the pony, don't get along very well at all. And, in fact, they have been caught fighting with scissors on more than one occasion. Chuck, the bear cub, eats paste by the forkful, and Annabelle, the duck, can't seem to stop wetting her pants in class.

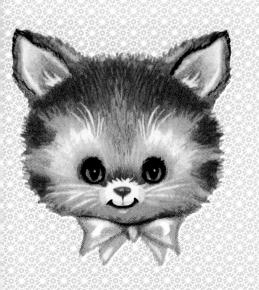

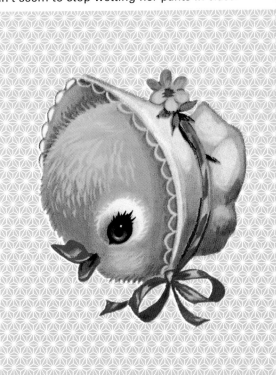

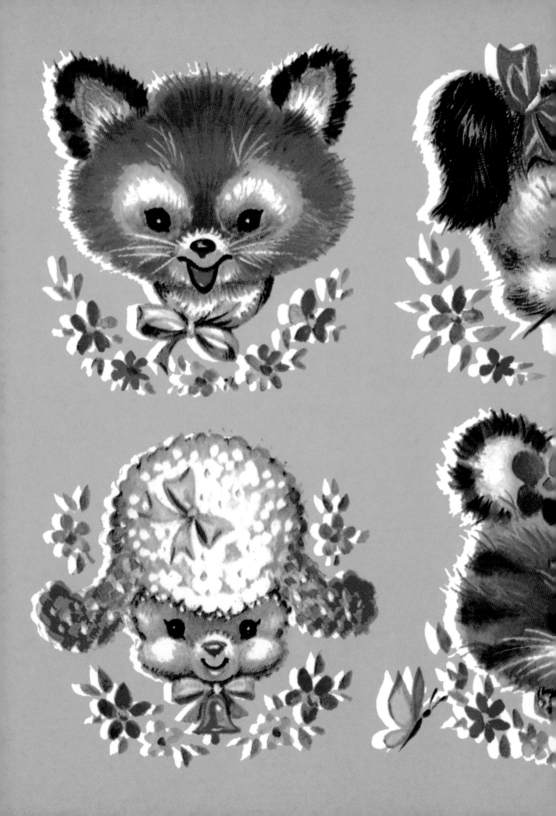

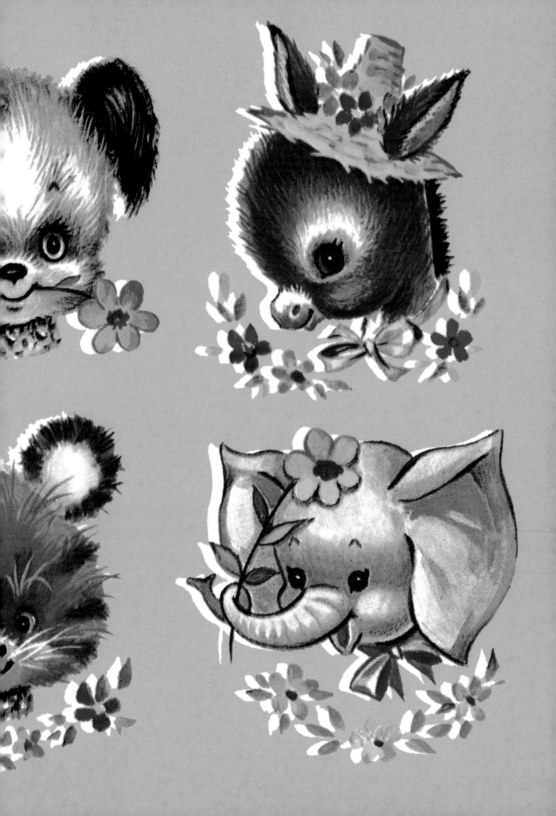

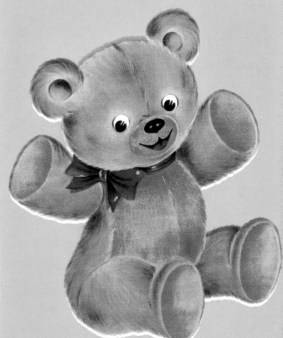

ANIMALS

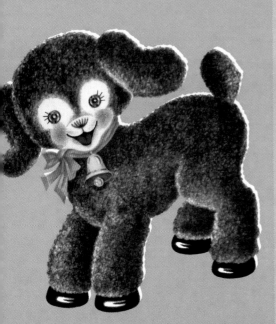
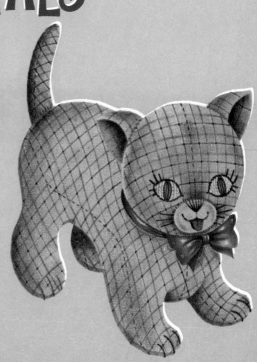

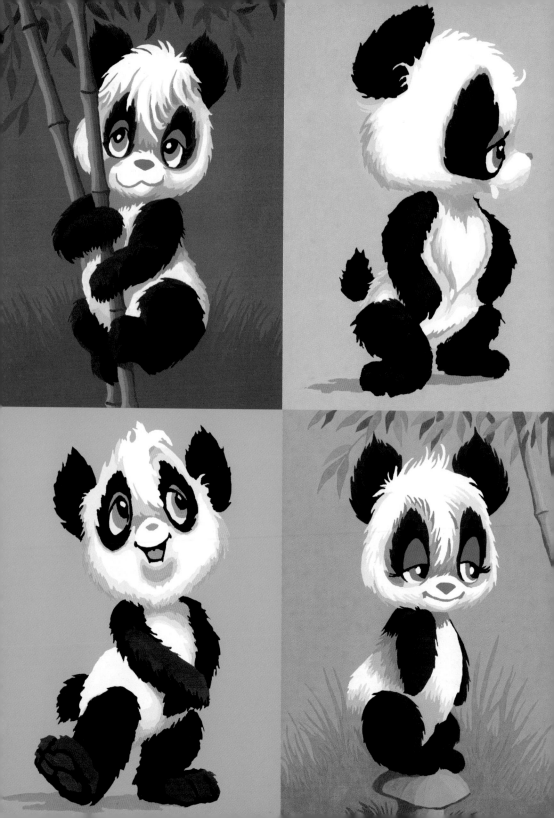

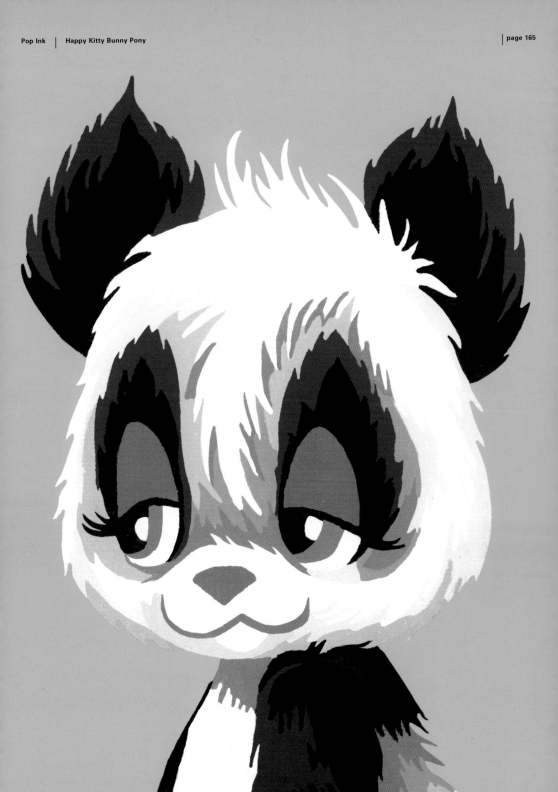

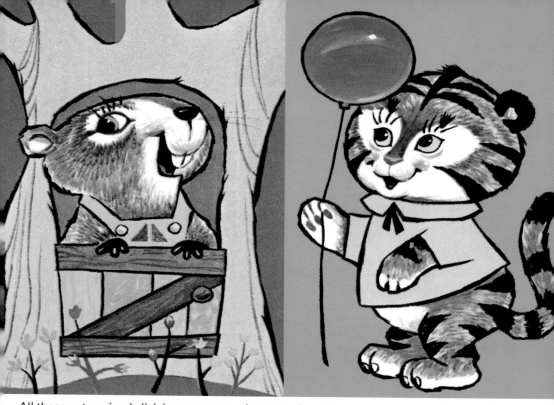

All these cute animal clichés are so true—beavers chop down trees, bears eat honey, tigers wear

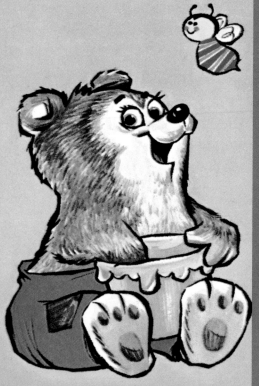

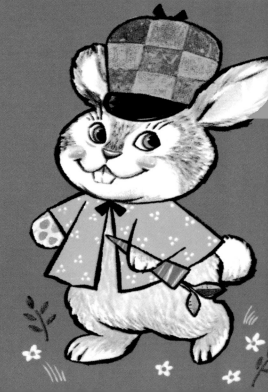

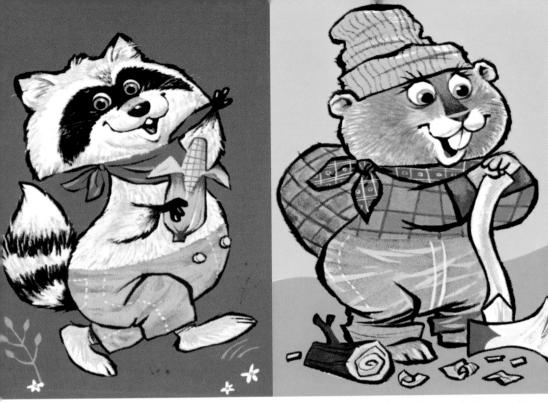

femmy little shirts and hold balloons, and foxes carry lanterns and put flowers in their hats.

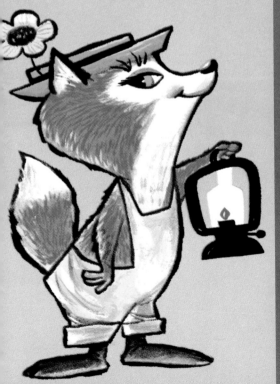

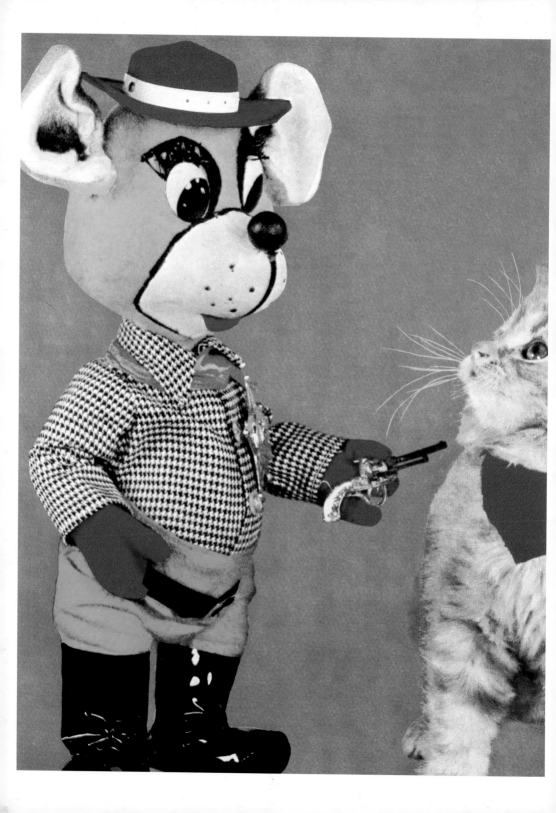

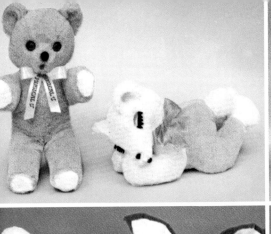

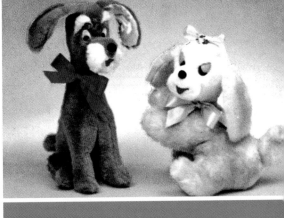

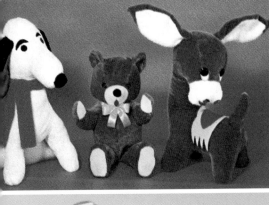

PALS

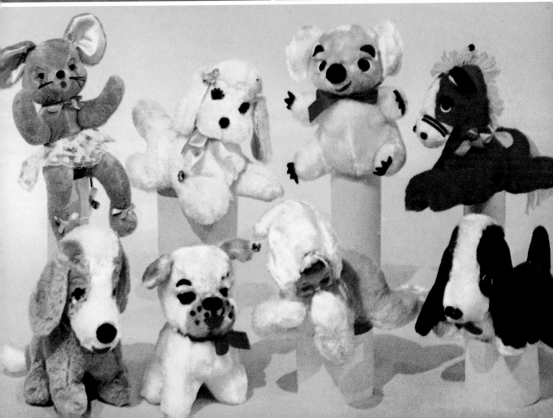

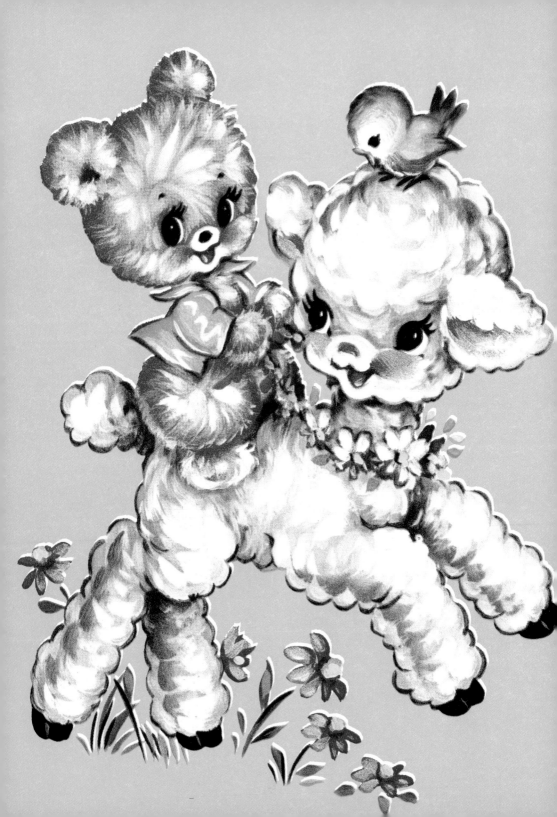

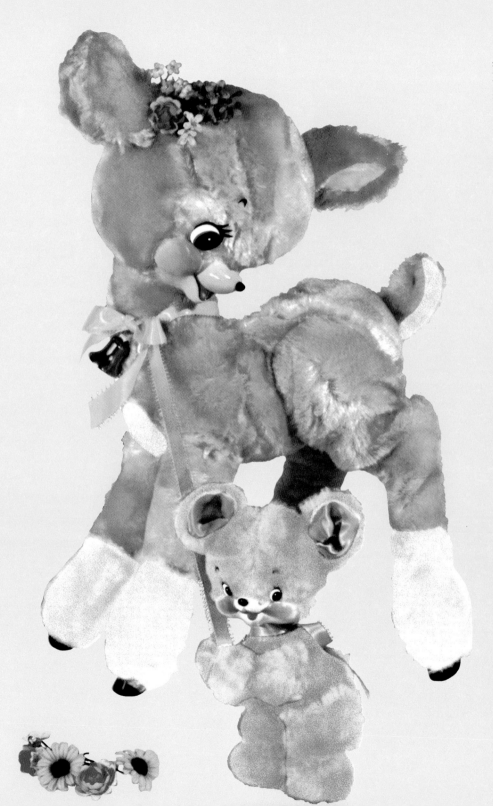

Here is a dark secret from the world of cute-dom: teddy bears have enslaved lambs and forced them to do their evil bidding.

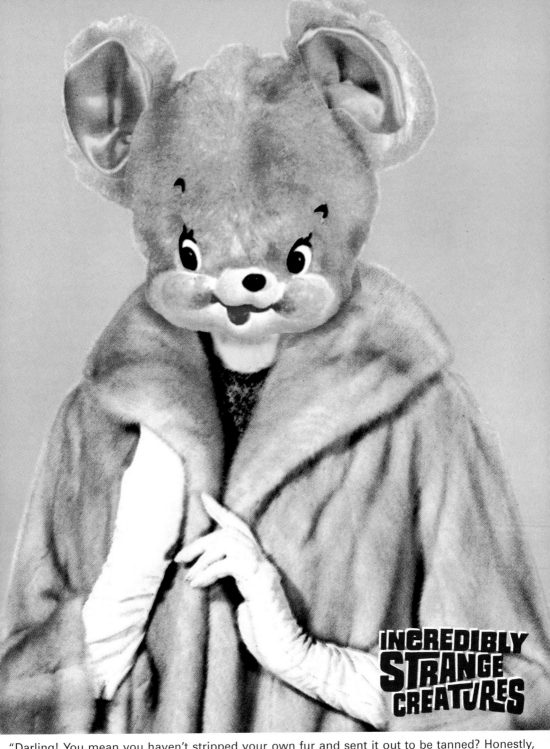

INCREDIBLY STRANGE CREATURES

"Darling! You mean you haven't stripped your own fur and sent it out to be tanned? Honestly, you must! It's simply divine. (Except for when they cut your fur off while you're still conscious.)"

Charles Spencer Anderson is a designer and pop culture junkie.

Pop Ink is the result of over fifteen years' worth of work by the Charles S. Anderson Design Company (est. 1989) and a lifetime's work by its founder. Fighting to humanize slick, impersonal corporate design, Anderson popularized the use of hand-drawn art, uncoated paper, and irreverent humor through work for long-time client and friend Jerry French of the French Paper Company. Charles S. Anderson Design Company's approach to design is a continuous evolution inspired by the highs and lows of art and popular culture. The firm has worked with companies as diverse as Barneys, Urban Outfitters, Coca-Cola, Target, Best Buy, Turner Classic Movies, Nike, Blue Q, Levi's, Ralph Lauren and Paramount Pictures. Their innovative identity, product, and package design has won nearly every industry award possible. Anderson has three sons, Matt, Blake, and Sam, and lives in Minneapolis with his wife, designer Laurie DeMartino, and their daughter Grace Annabella.

Charles S. Anderson Design Company's work has been influential in the industry both nationally and internationally and has been exhibited in museums worldwide including: The Museum of Modern Art, New York; The Nouveau Salon des Cent-Centre Pompidou, Paris; The Smithsonian Institution's Cooper-Hewitt National Design Museum, New York; and The Institute of Contemporary Arts, London.

Built in 1884, this renovated historic building, located in Minneapolis's warehouse district, is home of the Charles S. Anderson Design Company.

124 North First Street
Minneapolis MN, 55401

Karen Heineck

Erik Johnson

Kyle Hames

Sheraton Green

Jovaney Hollingsworth

Haley Drab

Each member of the CSA team brings an individual aesthetic that continues to evolve our design approach.

Writer / Actor Michael J. Nelson served as head writer for ten seasons and on-air host for five seasons for the legendary television series *Mystery Science Theater 3000*. He is the author of *Mike Nelson's Movie Megacheese*, *Mind Over Matters*, and the novel *Death Rat*.

VISIT THESE SITES: WWW.POPINK.COM WWW.CSADESIGN.COM WWW.CSAIMAGES.COM

Published in 2005 by Harry N. Abrams, Inc.
115 West 18th Street, New York, NY 10011
www.hnabooks.com
a subsidiary of La Martinière Groupe

Design by Charles S. Anderson Design Company
CSA Design, 124 North First Street, Minneapolis, Minnesota 55401
www.csadesign.com

Images by Pop Ink
www.popink.com

K Y M C K Y M C K Y M C K Y M C

Library of Congress Cataloging-in-Publication Data

Ink, Pop.
 Happy, kitty, bunny, pony : a saccharine mouthful of super cute / Pop Ink ; introduction by Michael J. Nelson.
 p. cm.
 ISBN 0-8109-9200-0
 1. Animals in art. 2. Animals—Miscellanea. I. Title.

NE962.A5I54 2005
704.9'432—dc22
 2004023833

Printed in China